THE
CREATIVE PERSON'S
WEBSITE
BUILDER

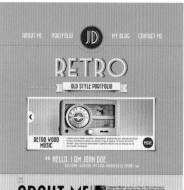

RETRO
OLD STYLE PORTFOLIO

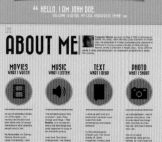

RETRO WOOD MUSIC

" HELLO, I AM JOHN DOE. "

ABOUT ME

MOVIES WHAT I WATCH **MUSIC** WHAT I LISTEN **TEXT** WHAT I READ **PHOTO** WHAT I SHOOT

PORTFOLIO

MY BLOG

CONTACT ME

LANDSCAPE

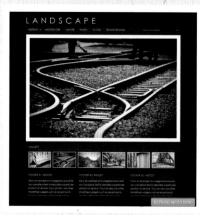

GALLERY

FOOTER #1 WIDGET FOOTER #2 WIDGET FOOTER #3 WIDGET

PRESS.

Press, a classy minimalist Wordpress theme

We are excited to finally launch our latest theme to come out of the Obox Signature Series, called 'Press'.

Press is a minimalist blog theme which can serve many different purposes. The nature of its design means the modifications are endless and the boundaries for content are only determined by you.

CONTINUE READING

Press, a classy minimalist WordPress theme — We are excited to finally launch our latest theme to come out of the Obox Signature Series, called 'Press'.

CONTINUE READING

Do you have a 'style'?

CONTINUE READING

Good design can drive traffic

CONTINUE READING

Look up and speak up

CONTINUE READING

THE REAL BEARS

Youtube Embed

CONTINUE READING

The Real Bears (Vimeo oEmbed)

CONTINUE READING

Craftiness

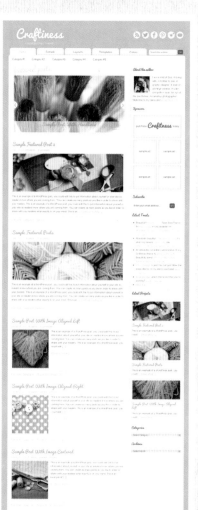

About the author

Sample Featured Post 2

Sample Featured Posts

Sample Post With Image Aligned Left

Sample Post With Image Aligned Right

Sample Post With Image Centered

Sample Post With an Unordered List

Vidley

STAFF PICK

EXIT passion

This is a Sample Video Post

Featured Content **Sample Widget**

Archives Widget

THE
CREATIVE PERSON'S
WEBSITE
BUILDER

How to make a pro website yourself
using WordPress and other easy tools

ALANNAH MOORE

HOW
BOOKS

CINCINATTI, OHIO
WWW.HOWDESIGN.COM

This book was conceived, designed, and produced by
The ILEX Press, 210 High Street, Lewes, BN7 2NS, UK

For Ilex Press:
Publisher: Alastair Campbell
Creative Director: James Hollywell
Managing Editor: Nick Jones
Senior Editor: Ellie Wilson
Commissioning Editors: Zara Larcombe
Art Director: Julie Weir
Designer: Kate Haynes

All images © their respective copyright holders. Every
effort has been made to credit the works reproduced
in this book. We apologize for any omissions, which will
be corrected in future editions, but hereby must disclaim
any liability.

Color Origination by Ivy Press Reprographics

Printed in China

Contents

Introduction

Perhaps you're a graphic designer, an illustrator, a photographer, or an archi-tect, and you need a slick and professional-looking online portfolio for your work. Perhaps you're an artist and you need an online gallery; a filmmaker needing to showcase your short films; or a musician wanting to let your fans hear your latest tracks online. Maybe you want to sell your craft creations to a wider audience, or you need to promote your books and your writing on the web. Or it could be that you just want to set up a photo or a video blog to share your creative impulses and insights with other like-minded people.

All kinds of creative people will need an online base or showcase to promote their work and connect with others. Luckily, there are the tools available to allow you to do this, without the necessity of seeking professional assistance.

While it won't be entirely free—you will always have the costs of hosting your website and there will probably be other expenses as well in getting your site exactly as you want it—creating your website yourself will cost you very much less than hiring someone else to do it for you.

The other benefit of learning how to do it yourself is that you can remain in charge. You can change the look of your site whenever you want, but just as importantly you can make sure that the content you put up there is up to date: your latest projects, your most recent clients, your upcoming exhibition dates, your latest musings or sketches, and so on.

It will take some effort to create your own website. You will need to have the perseverance to understand a little technical stuff, but it's not technical stuff that is beyond the reach of most people who are comfortable working with their computer, and it will allow you to get the beautiful-looking and engaging website that you're aiming for. It's most likely that, being a creative person,

you will find the challenge of putting together your own website, and the satisfaction of having created something you're proud to show people, well worth the effort you've put into it.

In this book we will look at some of the beautiful and exciting websites out there that belong to creative people like yourself; these will inspire you and show you elements that you can recreate in your own way on your own website. We'll then introduce you to WordPress, a fabulous platform allowing you to use a low cost, or free, commercially created template to get a website that looks entirely unique.

Just to make sure you get to grips fully with the nuts and bolts of working with WordPress, we will go into more detail and show you how to create a portfolio/blog site and an e-commerce site, either of which can be used as a starting point for your own website.

Of course, just as important as creating your website is letting the world know about it once it is up and online, and we'll fill you in on this know-how in the later chapters of the book.

Good luck, and enjoy the creative process of building your own website, and the satisfaction of using it to show your work to other people.

Technology and fashions change quickly.
Keep up to date by referring to the companion
website that accompanies this book at
http://www. creativepersonswebsitebuilder.com

1 GETTING THE BASICS IN PLACE

What do you need to get started?

You will need:

* A computer. (It doesn't matter whether you use a Mac or a PC.)
* An internet connection—everything you do to build your website, you will do online using your internet browser (Internet Explorer, Google Chrome, Firefox, Safari, or Opera, whichever browser you normally use).
* Image-editing software. Many creatives will already use Adobe Photoshop, but if you don't, you can use a basic free online service such as Pixlr.com (http://pixlr.com) or the free software Gimp (http://www.gimp.org; for both Mac and PC).
* A pen and paper to jot down ideas as you surf the web and leaf through the pages of this book.

You will also need:

* A domain name.
* Hosting for your website.

Your *domain name* is your website address. It will look something like: www.yourdomain.com.

Your *hosting* is the space you rent in cyberspace, in which you will construct your website.

Sometimes it makes sense to buy your domain name and your website hosting together.

There are numerous companies through which you can obtain a domain name and your website hosting—we'll look at some of these on pages 16–19.

Pixlr is a very useful free online image-editing tool for those without access to a specialized graphics program.

An alternative to Adobe Photoshop is Photoshop Elements which costs a fraction of the price. It lets you achieve great effects on your photographs, as well carry out other tasks, such as resizing images.

Building your website: the process

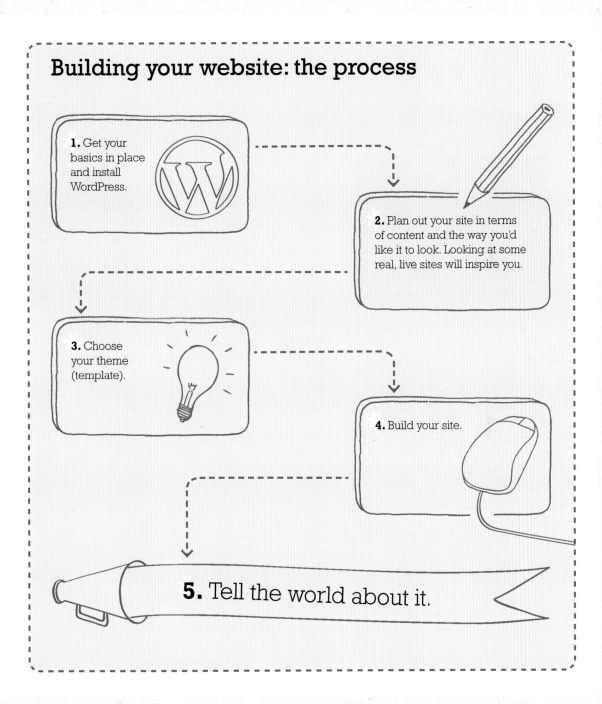

1. Get your basics in place and install WordPress.

2. Plan out your site in terms of content and the way you'd like it to look. Looking at some real, live sites will inspire you.

3. Choose your theme (template).

4. Build your site.

5. Tell the world about it.

The beauty of WordPress

WordPress is a free system that allows you to create a stunningly professional-looking website without having to learn how to program.

It's an immensely popular system—at the time of writing, 17.4 percent of all websites are built using WordPress, far more than any other platform. WordPress is a great solution for creatives because:

✳ A vast number of designs are available to you.
✳ There are layouts suitable for all kinds of creative websites.
✳ You can make your site look completely unique.
✳ You can keep your site up to date with the very latest information about your work and your projects.
✳ It's free to use.
✳ The designs you can choose from are very good value—some are even free.

✳ You don't need any complicated technical know-how.
✳ It's relatively simple to use, so you don't waste your time when you should be concentrating on your main creative projects.
✳ You don't need to ask a web designer every time you want to make a change.
✳ There's a helpful support community.
✳ Dozens of add-ons can make your site do exactly what you need it to do.*
✳ You have complete control over your website.*

* Only applicable to the self-hosted version of WordPress. There is another version of WordPress that is hosted for you, but its scope is more limited (see overleaf).

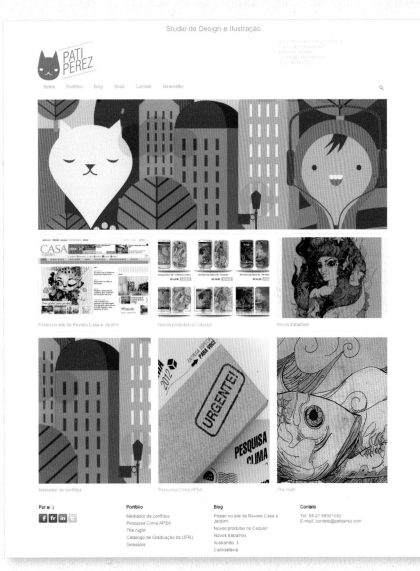

http://www.patiperez.com (Architekt theme, Dessign)

In a nutshell, setting up a WordPress site works like this:
1. You install WordPress on your web host.
2. You choose the design ("theme") that you want to use.
3. You customize the site and add your own content.

Which version of WordPress is right for you?

There are two versions of WordPress available:

* The version that you install on your own website, known as "self-hosted" WordPress.
* The version that is hosted by WordPress for you, known as "WordPress.com."

"Self-hosted" WordPress is the version we will concentrate on in this book. It allows you absolute flexibility in terms of the design you choose and the extras ("plugins") you add to your site; you also have total control over it, in that the system, and your content, will be hosted by your own hosting company, rather than by WordPress.

The flipside, of course, is that the technical aspect is entirely your responsibility, from installing WordPress to the maintenance of your website.

For some users, WordPress.com will be ideal in that it is very quick to set up and you will also get a certain amount of instant website traffic from the WordPress.com community.

In summary, if you want to start a creative blog, such as a crafting, cooking, or writing blog, it could be that WordPress.com is the better solution for you. But for anything more complex than a blog, you will want to go down the self-hosted route.

Note also that if you're planning on selling from your site, self-hosted is the only option available to you, as apart from a simple PayPal "donate" button, you can't add e-commerce features to a WordPress.com blog.

WordPress.com is a quick and easy way of getting a blog set up.

WordPress.org is the home of the self-hosted version of WordPress—the best solution for most creative websites.

WordPress.com or self-hosted WordPress?

	WordPress.com	Self-hosted WordPress
Quick to set up	Yes	Quite quick
Easy to set up	Yes	Quite easy
Your own domain name	Yes (optionally)	Yes
Technical knowledge required	No	Some
Responsibility for backups	No	Yes
Ads on your site	Yes, sometimes (unless you pay to remove them)	No
Ability to add plugins	No	Yes
Number of themes (designs) available	Limited (only the ones they allow you to use)	Unlimited (any theme you like)
Customization/tweaking behind the scenes	Limited	Unlimited (you can get a programmer to tweak the code, if you ever need to)
Instant traffic	Yes	No
Unlimited storage space	You pay for extra space	Determined by your hosting company, often unlimited
Costs	Free. Optional paid-for add-ons such as no ads, optional paid-for themes, and your own domain name	You need to pay for your own hosting and of course your domain name. Optional paid-for themes

Choosing your domain name

It's most likely you'll want either your name or your business name as your domain name. If the domain name you want is not available, there are plenty of ways of using your creativity to think up an alternative.

One way of coming up with a fun and memorable domain name is to experiment with unusual domain name extensions like .it, .to, .be, or .me.

A tool such as Domai.nr will throw up the different options available if you type in a word as a starting point.

Some examples of fun and clever domain names that use an unusual extension are:

isitraining.in
teddy.is
taskk.it
dr.aw
designm.ag
blo.gs
chi.mp
ma.tt
foot.ie

Which extension to choose?

I would always advise .com rather than .net or .org because it is often assumed in any case and you don't want to cause confusion—and it also just looks more professional.

A country-specific extension such as .co.uk or .fr is useful if you want to indicate that your business or practice doesn't have global reach, for example, if you don't want to ship your products or offer services outside your country.

> **✴ TIP**
>
> Avoid hyphens—you don't want to have to point them out each time you quote your domain name. (But this doesn't stop you purchasing the hyphenated version of your domain name in addition to the domain you're actually going to use, in order to stop others acquiring it.) If someone has already bagged the domain name you wanted, it's better to choose something different, rather than settle for the hyphenated version instead.

> **NEW DOMAIN NAME EXTENSIONS**
>
> As of 2013, many new extensions are due to become available such as .art, .agency, .architect, .book, .blog, .design, .film, .movie, .band and .music.

Domainr

search

When you want a short URL or something big, Domainr will find it, fast. Some of our favorites: **resu.me**, **urlte.am**, and **soc.io**.

Find More Domains
NameLayer is a curated market for entrepreneurs.

Resources for Startups
We use and recommend Papertrail for hosted log management. See more »

About | Features | Registrars | Top-Level Domains | API | Email Us | Forum | @Domainr | Apps for iPhone, Windows Phone, and Chrome
Lovingly made in San Francisco by @case, @ceedub, @connor, and @rr. © 2012 nb.io

Tweet 1,606 Like 901 Pin it

Domai.nr is a great place to get ideas for inventive domain names using unusual domain extensions.

Dot-o-mator

Domain Naming Tips | Web 2.0 Name Generator | for iPhone

Use Dot-o-mator to create domain name suggestions. Just enter a word (or words) in the left box, and choose some endings (or enter your own). Click to combine them. If you see a name you like, you can check its availability or save it to your scratchboard.

There is a max of 15 words in the prefix and suffix boxes (so as not to overwhelm the bulk lookup tool).

Beginnings **+** **Endings** [Combine] **Results:** **Scratchboard**

Name Lists Name Lists Check Availability [Check] [Clear]
--Choose/Clear-- ⬍ --Choose/Clear-- ⬍

Or type some words: **Or type some words:**

Get Dot-o-Mator
for your **iPhone!**

Find out more ▶

Want to help improve Dot-o-mator?
Take the survey!

Questions/feedback?

Dotomator.com can help you come up with domain name ideas by combining words.

Registering your domain name

Domains are registered with a company called a registrar. It's important that your domain is registered with a reputable registrar.

Your hosting company (see overleaf) will often include a domain name as part of their package; this is convenient in that it means dealing with one company instead of two.

However, if you are choosing a domain name with a country-specific or more unusual extension, it's likely that your hosting company will not be able to offer registration for the domain. In this case, you'll need to use a separate registrar.

Two well-known domain registrars are:
http://www.namecheap.com
http://www.godaddy.com

For international registrations:
http://www.gandi.net
http://www.101domain.com
http://www.marcaria.com

* **TIP**
Make sure you register your domain name using an email address you check regularly. You will receive renewal reminders by email to the address you signed up with.

Gandi.net offers good prices for some international domain extensions.

* **TIP**
Do compare prices. For example, at the time of writing there was a very significant difference between Gandi and Marcaria in the pricing of a .fr domain name.

Godaddy and Namecheap are two well-known and reputable domain name registrars.

* **TIP**
 You may be offered hosting by your domain name registrar. My advice is always to go with a specialized hosting company (see over), and if they offer you your domain as well, all the better.

Hosting

You need a hosting company with the following criteria:

✳ It must be capable of running PHP and MySQL* (in order to run WordPress).

✳ It should feature a "one-click" WordPress install**, which will make your setup quick and easy.

✳ It must offer 24/7 technical support.

✳ It must have an excellent "uptime" record—i.e. 99/100% (you don't want your website to be "down," ever).

In addition, you may want to choose a hosting package that offers you:

✳ unlimited storage

✳ unlimited bandwidth

✳ unlimited databases

✳ unlimited email addresses

… in case you want to set up other websites, use your web space to store files, or anticipate a vast amount of traffic to your site.

When signing up for a hosting package, it's likely that a "shared" hosting package*** will be perfectly adequate for your needs. If in doubt, ask the hosting company, but for the vast majority of cases, it will suit your needs more than sufficiently.

***About PHP/MySQL:**
PHP is a programming language and MySQL is simply the name of the database system your site will be using—there's no need for you to know anything about these to set up your site.

**** About the one-click install system:**
You may see this named as Simple Scripts, Fantastico, Installatron, or something else—it doesn't matter which one-click system your host provides.

***** About "shared" hosting:**
"Shared" hosting simply means your site will reside on a server that is shared by other users. This is the most common hosting option, and you'll never be aware of the other users or actually share anything with them.

If you're going to set up a blog with WordPress.com, you won't need a hosting package, and you'll probably buy your domain name directly through them.

MY RECOMMENDATIONS FOR HOSTING ARE:

✳ DreamHost http://www.dreamhost.com
✳ Bluehost http://www.bluehost.com

These hosting companies are recommended by WordPress themselves and they both tick all the boxes mentioned to the left. It is worth looking at both the companies as they often offer special prices.

A LOCAL HOSTING COMPANY?

If you speak a language other than English, you may prefer to set your hosting up with a local hosting company, so that the customer service can help you if you have a problem. It's also worth asking if they can install WordPress for you in your own language.

CHANGING YOUR NAMESERVERS

If you've registered your domain name with a registrar and not via your hosting company, you'll need to connect the domain name and the hosting together, so that your website shows up on your domain name. Your hosting company will provide you with the nameservers you need; log into the management area of your domain name registrar, look for the option to "Transfer DNS to Webhost" or "Change Nameservers," and paste this information into the fields provided. After you've saved the settings, you may have to wait some time to see any change—you'll know you can begin to work on your new site when you see a holding page appear on your domain, as shown below. (This may take up to 24 hours, though is usually much faster.)

Changing your nameservers to DreamHost's for a domain name registered at Namecheap. (The nameservers your host gives you may be strings of numbers instead; you normally only have to fill two or three of the fields given, as shown here, leaving the others blank.)

A hosting package offering you unlimited space, as with both DreamHost and Bluehost, is an advisable option to go for—you'll never have to worry about uploading too many images or other content to your site.

Setting up with WordPress.com

Just to recap, WordPress.com is the version of WordPress that is suitable for blogging, but limits your options for a full-blown site. Most creatives will be using the "full" version, which we'll see how to set up over the page. Setting up a blog with WordPress.com will take just a couple of minutes.

Click the orange button to get started.

You can change your blog address later if you wish, however if you plan to use your own domain name, your wordpress.com blog address will never be visible.

While setting up, you'll be taken through a series of steps, including choosing and customizing a "theme" (template) and writing your first blog post. It's not a problem if you're not yet ready, as you can access all of the steps again later.

If you're unsure at this stage which of the paid-for features you will need, sign up for the "Basic" free version. You can always add a domain name later, or the other features offered by the "Premium" bundle (at the same value).

GET INSTANT TRAFFIC TO YOUR BLOG

When you create your blog posts, make sure you assign tags and categories to them, as this will help your blog appear in the "Topics" list and bring you a flood of new readers.

Once you're up and running...

Here is where you can follow the latest blog posts of the topic areas that interest you.

Click here to add a blog post to your blog (you can also do this from the admin area).

Here is where you access your blog to customize and edit it via the administration area (see the screenshot below right).

Access your blog's administration area by clicking this link.

Purchase your upgrades here (including your domain name).

Create and manage your blog posts here.

Create static pages for your blog here (such as an "About" or "Contact" page).

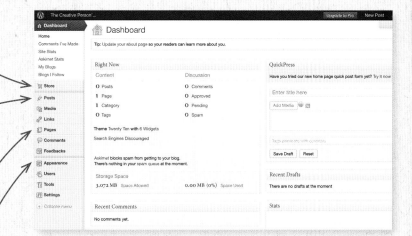

Change and customize your website theme here; add "widgets" to your sidebars.

Your blog's administration area

Happy creative blogging with WordPress.com!

Setting up with self-hosted WordPress

Self-hosted WordPress is the full-blown version of the software that most creative people will want to use. If you've chosen a hosting company with a one-click install, your self-hosted WordPress setup will be very easy indeed. Your web host will guide you through the process and all you'll need to do is follow their instructions.

You will want to install WordPress so that it is on the "root" of your site. This means that when site visitors go to your domain, they will see the site straight away. So, select your domain from the drop-down menu and leave this box blank (don't create a separate folder).

Installing WordPress with DreamHost

The Dreamhost one-click install takes place from within the Goodies > One-Click Installs area. You'll need to click the link in the email the system will send you to complete the installation.

When you've completed your install, you can log in at http://www.yourdomain.com/wp-login.php. We'll carry on with the technical side of creating your website in Chapter 6.

If you're using a different web host, your WordPress installation will not be done in precisely the same way, but you will be guided through the process by the instructions in your control panel.

Installing WordPress with Bluehost

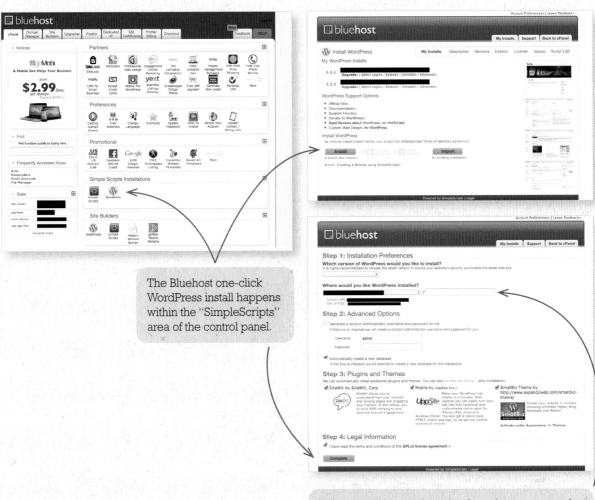

The Bluehost one-click WordPress install happens within the "SimpleScripts" area of the control panel.

Select your domain from the drop-down menu and leave this field blank, so that your site visitors will see your new website straight away when they visit your domain (don't install to a separate folder).

PLANNING YOUR SITE

Let's look at what you might want to include in your website, before looking at some actual live sites and taking further inspiration from them, both in terms of design and content.

WHAT KIND OF CREATIVE PERSON ARE YOU, AND WHAT IS THE AIM OF YOUR SITE?

Blog
Including a blog on your site is a way of keeping your site dynamic, your site visitors interested, and your creative juices running. It's more and more common for websites of all kinds to include a blog or photo/video journal as an integral part of the site.

Showcase your portfolio or gallery
Graphic designers, illustrators, architects, and artists need to display their work to prospective clients with an online portfolio or showcase.

Let your fans listen to your music online
Include samples or longer snippets of music to be played directly from your site; keep in touch with fans and announce upcoming gigs or concerts.

Showcase your writing
Writers need a home base to keep in touch with their readers, showcase drafts and excerpts, and announce upcoming works.

Connect with social media
Integrate your site with Facebook, Twitter, Flickr, and other social media to spread the word to the broadest audience possible.

The type of website you are going to build depends on what kind of creative person you are, and what you want your website to do for you.

Present your videos on your website
It's easier than ever to show videos on a WordPress site: videos hosted on YouTube, Vimeo, and other third-party video-viewing sites can be seamlessly integrated, either as an entire background or with a specially designed video site layout, ideal for actors and filmmakers.

Sell your craft items online
The web makes it easy to reach a much broader audience of buyers than you'd ever come across otherwise. Beautiful templates designed especially for e-commerce make it simple to show off your creations in a store layout.

There are thousands of themes ready for customization, suitable for all kinds and styles of creative websites.

Clockwise from top left:

FontFolio (Dessign)

Snapcase (designcrumbs, ThemeForest)

Portfolio Theme (Organic Themes)

Un Altro (room122, ThemeForest)

Gigawatt (Obox Themes)

PictureThis (CadenGrant, ThemeForest)

Indie Fest (Foxhound Band Themes)

Getting inspiration

The best way to get inspiration for your own site—in terms of both content and design—is to spend time surfing around with a pen and paper in hand.

What will your website look like?
It will reflect you and your work, but keep in mind what kind of image you are trying to project, and to whom.

* Professional
* Quirky
* Homemade
* Personal

* Modern
* Trendy
* Classic
* Minimal

✳ TIP

Make a visual record of sites that grab your attention using the built-in print screen function on your computer. On Mac, press Command + Control + Shift + 4, then space, click a window, and paste into a Word, Paint, Photoshop, or other document; on PC, click on the window you want to copy, then press Alt + Prnt Scr, and paste into a document.

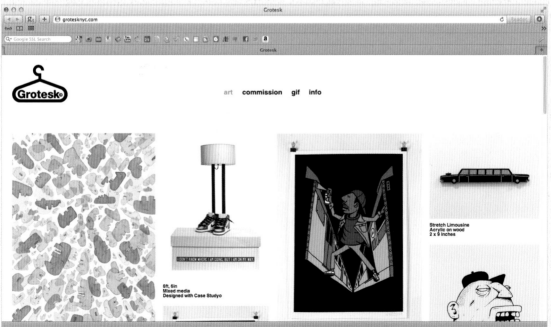

Grotesk—http://grotesknyc.com

The content of your site: the pages you need and other ideas

Every site needs a "Home" page—the page that gives the first impression of you and your work. You will want to impress on the first page, so think about what you want to show there. Your best works, in a rotating viewer, perhaps? Or some selected works?

Do you want to explain what you do "in a nutshell," or will you let your works speak for themselves?

The other page a site absolutely needs is a "Contact" page; most sites have an "About" page as well.

What other pages and elements will you want to include?
A sketch for the setup of a photographer's site might look something like this.

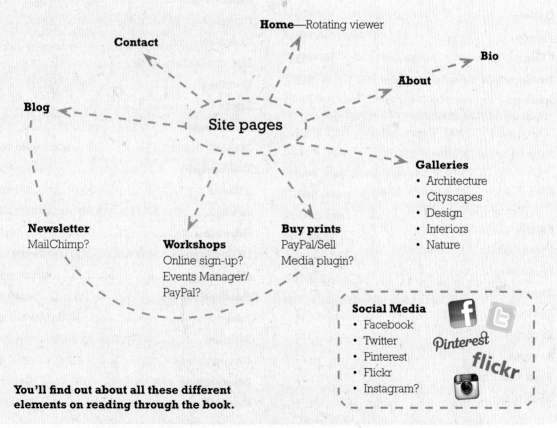

Home—Rotating viewer

Contact

Bio

About

Blog

Site pages

Galleries
- Architecture
- Cityscapes
- Design
- Interiors
- Nature

Newsletter
MailChimp?

Workshops
Online sign-up?
Events Manager/
PayPal?

Buy prints
PayPal/Sell
Media plugin?

Social Media
- Facebook
- Twitter
- Pinterest
- Flickr
- Instagram?

You'll find out about all these different elements on reading through the book.

Blogging on your site

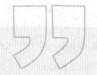

WordPress was originally created as a blogging tool, and even though it's developed in leaps and bounds from its early days, all websites created with WordPress are built to feature a blog as an integral part of the site, as we'll see in more detail in Chapter 6.

You don't have to use the built-in blog on your site, but blogging is an ideal tool for creative people. Your site visitors will be able to transition seamlessly from the more formal, static, pages of your site into the more personal and dynamic part of it, thereby giving you the chance—by sharing more of your thoughts, material, inspirations, and so on—to make a memorable and lasting impression.

Blogging is a great idea because:

* Google loves sites that are updated often.
* It makes you look dynamic and current.
* It's a great way to show off the projects you're working on, and your skills.
* It adds immediacy and life to your site.
* It's an opportunity for interaction between you and your site visitors.
* It shows a less formal side to you or your business.
* You can add all kinds of different material and make your site more individual and engaging for your readers.
* It gives you the chance to show the background to your projects and flesh out your visitors' knowledge of you and your work.
* Your readers can sign up to receive blog posts by email, which means you have a way of keeping in touch with them.

BLOGGING IDEAS FOR CREATIVES

Inspirations and influences

Background to the creative process

Your opinions on matters related to your work or your field. Comments make it possible to kickstart a debate

Progress of works (film, book)

Sketches

News of upcoming exhibitions, gigs, other events

Asking for feedback

Quotations

Videos

Asking clients to send in pictures of themselves with their creations, wearing or using the products you have made

Photos

Snips of poetry, excerpts of books

Asking fans to send in photos of gigs, etc.

Reviews

BLOG POST FORMATS

Most newer WordPress themes allow you to display blog posts in different formats including image or video posts, status updates, quotations, and web addresses. This makes it less challenging to keep your blog up to date, without the pressure of spending time and energy creating a fully fleshed out blog post, each and every time you have something to say.

Gridlocked theme by Themezilla (Themeforest) is an example of a theme that can display different layouts of blog post.

Danielmeetsdesign http://www.danielmeetsdesign.com

Boudist http://www.boudist.com

Featuring a blog on your site gives life to the impression of you, your business, or your creations that's presented by the more formal side of your website.

Posting from your smartphone or tablet means it's easy to post while on the move—another incentive to keep your blog lively and right up-to-the-moment.

INSPIRATION

The following pages show some impressive websites that offer some wonderful take-home ideas for you as a creative person to implement on your own site. You'll be using a pre-designed theme, so you won't have complete free rein as to the layout of your own site—you are not designing and programming it from scratch— but you'll be able to adapt and incorporate some of the ideas you find here within the design you eventually choose. (We'll be looking at themes, and where to get them, in Chapters 4 and 5.)

Alexa Falcone,
freelance designer, U.S.
http://www.alexafalcone.com

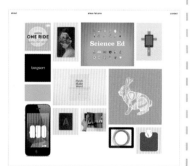

Graeme Swinton,
designer, London, UK
http://www.swinton.me

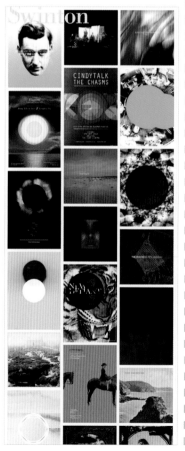

I am always hungry, design
studio, New Orleans, U.S.
http://work.iamalwayshungry.com

* Three examples of portfolios using a solid block or "masonry" style layout.

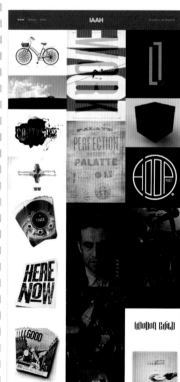

Built by Buffalo,
web design, Brighton, UK
http://builtbybuffalo.com

* Hexagonal thumbnails are
 an unusual way of displaying
 portfolio content.
* Different elements of content
 follow each other down the
 page, approaching the
 one-page design that is
 an increasing layout trend.
* The flat, colored graphics
 seen on the site are very
 much in vogue.

Mariusz Cieśla, web and
mobile interface designer,
Krakow, Poland
http://mariusz.cc

* An inspirational
 implementation of the
 one-page layout for a
 personal/professional site,
 combining photographs,
 colors, and graphics.
* Giving the background and
 showing sketchbooks brings
 the chosen projects into focus.

We Are Mammoth, web app
designers, Chicago, U.S.
http://wearemammoth.com

* Two nice ideas here
 (apart from the gorgeous
 smooth layout): shots of
 the offices, and sketches
 of work (see the live site).

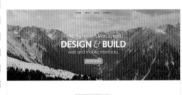

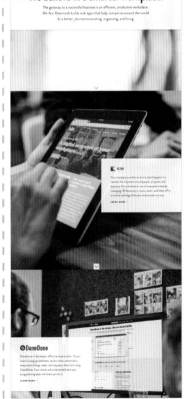

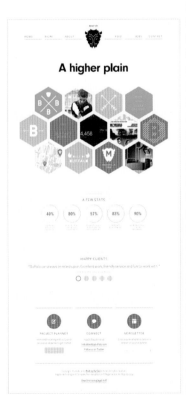

INSPIRATION

**Control, Video Production
Company, Paris, France**
http://controlfilms.tv

✳ A beautiful, clean site with
a scroll-down feature.

**Rafael Viñoly Architects,
New York, U.S.**
http://www.rvapc.com

✳ The background is a full-screen
video of the architect's hand
sketching a design.

**Pablo González,
film director,
Bogotá, Colombia**
http://pablo-g.com

✳ Full-screen photos and large
type make this simple layout
striking—the images speak
for themselves.

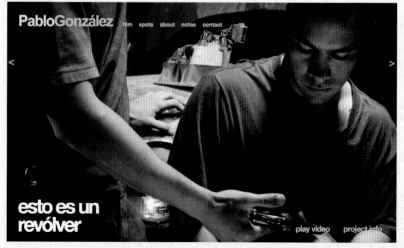

**Andrew F,
photographer,
Manchester, UK**
http://www.
andrewfphotography.com/
portfolio

✳ A slick, full-screen portfolio.

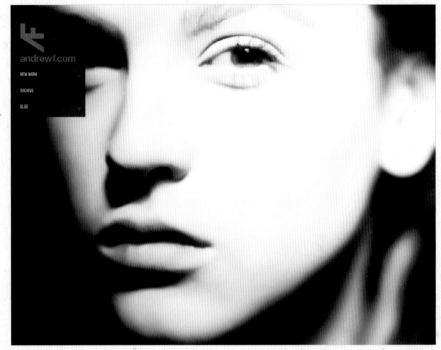

**Chris Phelps, photographer,
New York/Texas, U.S.**
http://www.chrisphelps.com

✳ Photos and videos scroll in from
the right—a good way of viewing
a lot of visual content with no
interruption while loading.

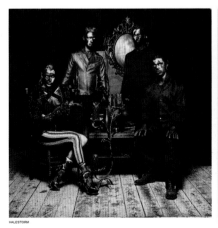

INSPIRATION

Josh Garrels, musician, Portland, U.S.
http://joshgarrels.com

* Great graphics and colors here for this musician's site—a completely different style from the one to the right.
* Features an integrated Topspin store; fans can submit their photos for inclusion on the site.

Beyonce's official site, international
http://www.beyonce.com

* Full-screen video clips on the home page.
* Also see the photo/press portfolio (labeled "Vault"), which uses a blocked layout, and the news area which has one full-screen element following on after another.

The Thomas Oliver Band, Wellington, New Zealand
http://thethomasoliverband.com

* A third, entirely different look for a music site—this one grainy and textured.
* A one-page layout is used incorporating all elements one after the other.

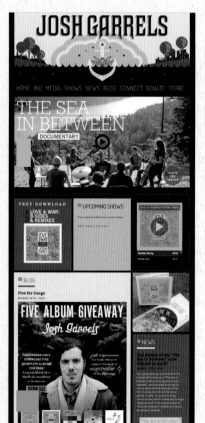

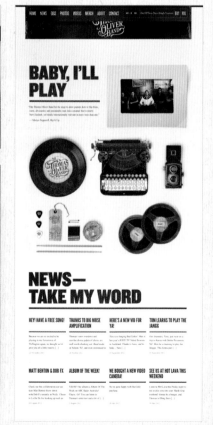

Mati Rose, artist,
San Francisco, U.S.
http://www.matirose.com

Abby Monroe, crafter,
London, UK
http://www.abbymonroedesign.com

The Calm Gallery,
online print gallery, London, UK
http://www.thecalmgallery.com

✳ Three e-commerce sites with an entirely different handmade feel, focusing on graphics and typography and highlighting the "homegrown," creative nature of the products. This is a popular look and feel for craft sites, and beautifully done in these examples.

✳ Mati Rose's site is integrated with vintage/craft marketplace Etsy.

AÃRK Collective, watch makers,
Melbourne, Australia
http://aarkcollective.com

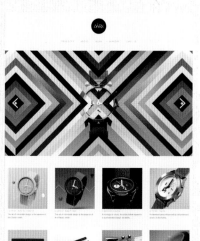

Eden Made, Germany
http://www.eden-made.de

✳ Two e-commerce sites showcasing commercial products—both inspirational in terms of presentation and photography.

INSPIRATION

Shamballa Jewels, Copenhagen, Denmark
http://www.shamballajewels.com

✳ This very beautiful jewelry site focuses on the "story" behind the creations. The blog part of the site, labeled "Journal," is composed entirely of photographs, building a visual background for the jewelry.

Dan Brown, author, international
http://www.danbrown.com

✳ Another one-pager—a great choice of layout for an author.

Amy Krouse Rosenthal, author, Chicago, U.S.
http://www.whoisamy.com

✳ Another author site, which couldn't be more different. Here, the cute graphics make it personal and individual, whereas the Dan Brown site is slick and, while graphics do make it individual, is much more commercial in feel.

Shel Silverstein, poet, cartoonist, screenwriter, and children's author, Chicago, U.S.
http://www.shelsilverstein.com

✳ A third author site. Again, the graphics make it completely individual. The intro is the artist's hand sketching.

**Mahédine Yahia, portfolio,
Paris, France**
http://www.mahedineyahia.fr

**Davy Rudolph, web designer,
New York, U.S.**
http://neueyorke.com

✳ The simple graphics on the
 category "labels" on the home
 page function as a kind of visual
 menu.
✳ The layout is extremely simple
 but the colors and minimal
 design make it striking.

**Johann Luccini, art director,
Paris, France**
http://johannlucchini.com

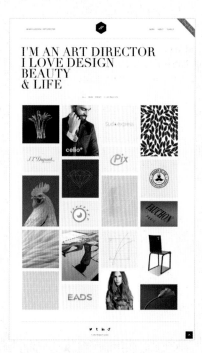

**Hangar, creative agency,
Malta**
http://www.madebyhangar.com

✳ A full-screen photo or video of
 where you are based makes a
 great place for visitors to land
 on your site (see also Mariusz
 Cieśla, page 33).

**Takumi, graphic designer,
Paris, France**
http://cmjnrvb.net

✳ A strong statement of who you
 are and what you do at the very
 top of your site is a striking way
 to introduce yourself.

THE WORLD OF THEMES

You can consider the theme you use as the skeleton of your WordPress website.

The theme is the template you choose to build your site with. There are hundreds of beautiful themes available for you to use, either free or at a low cost—a snip compared to what you would pay a designer to create a site for you.

The theme you choose is essential. While we can say that the content of your site is actually what is most important, as a creative person you will be acutely aware that the visual impression you give will determine the impact you make on your site visitors. It is hugely important that your site conveys the right image in order to present you and your work in the way that you want to be presented.

It is also important that you choose the right theme in terms of site structure, because while many themes are highly customizable, with others (most commonly the free ones), your layout will be determined to some degree for you by the theme.

So, your choice of theme is crucial—even more so for you as a creative person, with a distinctive visual image to convey.

Things to know about WordPress themes:
* There are hundreds of themes available.
* Some of them are free, others you have to pay for (these are usually described as "premium").
* Premium themes are priced somewhere between $19 and $97.
* They are created by individual designers.

* There are layouts available for all kinds of site.
* Levels of post-sale support vary.
* Some themes are highly customizable, others are much less so.

To pay or not to pay?
* While there are some great free themes, on the whole, premium themes tend to look more slick and professional.
* Premium themes usually offer more built-in (optional) features.
* A small number of free themes are highly customizable, but as a general rule, premium themes are much more so.
* You will probably get better support with a theme you have paid for.

In summary, if you compare the cost of getting a designer to build your site with the cost of a premium theme, you will find that paying for a theme is amazing value; if you factor in the importance of the impression you create on your site visitors, to me, it's clearly worth paying to get the right theme.

However, if you haven't budgeted for a premium theme, you'll find that there are still some excellent options available to you.

Two themes by WP Explorer (http://www.wpexplorer.com).
Portafolio is a very nice, clean, free theme, but with Foxy
Portfolio, a premium theme, you get far more options,
for example a drag-and-drop interface so that you can
completely rearrange the home page; it's also responsive.

Grid Portfolio by Dessign (http://www.dessign.net)—a minimal
portfolio theme suitable for showcasing all kinds of visual work.
The basic version of the theme is free, but to get the responsive
version that shows your works in a cell phone-friendly layout,
you have to pay.

How to choose a theme

The number of beautiful themes that have been created for WordPress is one of the good reasons for using it—but precisely because there are so many themes available, and so many independent creators, it can be difficult to choose between them. These considerations may help you.

Be clear on what kind of site you are creating. Is it:

* A blog?
* A portfolio or showcase?
* An online store?
* A "magazine" site?
* A blend of two or more types—for example, a blog with a store attached (or vice versa), or a site presenting your business, with an integrated portfolio?

Do you require special features, for example:

* A slider on the front page?
* A built-in portfolio?
* Full-screen viewing of images or videos?
* E-commerce?
* Built-in testimonials?

✳ TIP

For the smoothest of setups, choose a theme intended for the kind of site you're about to build, and one that is already as near as possible in design and layout to your ideal site. By the time you've put in your own logo, your content and images, and changed the background—and with some themes the font also—your site will look totally unique. So take your time choosing your theme—it'll pay off.

* A built-in "team" section for details of each individual involved?
* Built-in facility to play music?
* A built-in events calendar?

There are themes especially created for all kinds of site, including for most kinds of "hybrid" site. While plugins (extras that can be added in; see Chapter 7) exist to make your WordPress site do pretty much what you want it to, your site may look slicker, and be easier to set up, if you choose a theme that is especially created for your purpose.

✳ TIP

Decide on what you need before you choose a theme. Make sure you find the theme that fits your needs, not the other way around. Don't choose a theme just because you like it—it's got to suit your purpose.

How customizable is the theme?

Themes vary as to how customizable they are, with more recent themes tending to be more customizable than older ones. If you want to change the colors, for example, check that this is a possibility, but it may be that you like the theme just as it is, "out of the box."

Can you change your page layouts?

Don't assume you can easily change the layout of your pages, in particular your home page. Check this, and if you can't change the layout, which is quite commonly the case with free themes, make sure the pages are laid out exactly as you want.

Do you need different blog formats?

More recent themes allow you to post to your blog with different formats (as mentioned previously: image, video, status, quotation, etc.). If blogging is a major feature of your site, it makes sense to make use of this innovation and choose your theme accordingly.

Do you need a specific portfolio structure?

Not all themes display work in the same way. You may need to organize your work by project and be able to show more than one image, plus text, for the projects. Other portfolios are "filterable," meaning that work is separated into categories. Check how the portfolio functions for a theme before making your final choice.

Does your site need to be responsive?

A responsive site adapts in format to fit a cell phone or tablet screen. For a portfolio site or a photo or video blog, it makes sense to choose a responsive theme so that your viewers can see your work to best advantage, whichever size screen they are using. Equally, for a site with a lot of written content, your readers must find it easy to read, particularly if they follow your blog while they are on the move—this means no text shrunk to unreadable proportions, or lines that don't fit the width of a smartphone screen. Furthermore, the proportion of purchases made from cell phones is increasing fast, so if your site is an e-commerce site, it's vital that you choose a theme that makes shopping on the move easy for your customers. However, choosing a responsive theme may not be absolutely necessary for everyone's needs; if in doubt, check the theme demo on a smartphone and see how it looks.

✳ TIP

Because WordPress themes are created by different individuals and companies, the language used to describe their functionality varies. If in doubt as to whether the theme will do what you want it to, ask the creator—there is often a special pre-sales comments area especially for this purpose.

IF YOU CAN'T FIND EXACTLY WHAT YOU NEED . . .

If you find a theme you really like but it lacks a certain feature you want to incorporate, don't despair. There is likely to be a plugin that will enable you to achieve what you want (see Chapter 7)—or you could have some custom programming or design done. But do check that among the hundreds of themes that exist, there isn't one built precisely with your needs in mind.

Good places to find themes

There are dozens of places to get WordPress themes. Here are some that are particularly good for creative themes. This isn't an exhaustive list, but these are the places I usually start with. (We'll look at some examples of themes in the next chapter.)

The WordPress Free Themes Directory (free)
This is connected to your WordPress administration area so you can access these themes directly.
http://wordpress.org/extend/themes

Graph Paper Press (free and premium)
Slick, modern themes for artists, photographers, and bloggers.
http://graphpaperpress.com

Dessign (free and premium)
An ever-growing collection of modern portfolio themes designed expressly for creatives—graphic designers, architects, typographers, photographers, and so on.
http://www.dessign.net

WPExplorer (free and premium)
Lots of great themes including a large number of beautiful free portfolio themes (in the "Freebies" section).
http://www.wpexplorer.com

ThemeForest (premium)
A mind-boggling array of themes of all sorts from hundreds of independent designers. Whatever you want, you will find it here.
http://themeforest.net

WPShower (free and premium)
Good selection of portfolio and magazine themes.
http://wpshower.com

Theme Trust (premium)
A collection of clean and minimal themes with a variety of portfolio layouts and some nice magazine/blog themes as well.
http://themetrust.com

Press75 (premium)
A great selection of slick-looking portfolio, photo, audio, and video themes.
http://press75.com

Organic Themes (premium)
A very nice collection of themes, focusing specifically on artists and bloggers.
http://www.organicthemes.com

ColorLabs (premium)
Nice clean modern designs—in particular some good e-commerce and photography themes.
http://colorlabsproject.com

WooThemes (free and premium)
A variety of attractive themes, including many portfolio, photoblog, and multimedia themes; this is also the home of WooCommerce, one of the best and most-used WordPress e-commerce plugins.
http://www.woothemes.com

StudioPress (premium)
Classic theme designs for all kinds of purposes.
http://www.studiopress.com

Elegant Themes (premium)
A good selection of portfolio themes, with their own distinctive style.
http://www.elegantthemes.com

Creative Market (premium)
A relatively new marketplace for independent designers with a good collection of themes of all kinds.
https://creativemarket.com

Foxhound Band Themes (premium)
Themes especially for musicians with built-in features (discography, tour dates, etc.).
http://foxhoundbandthemes.com

WPZoom (premium)
Glossy, professional-looking themes with a good selection of photography, portfolio, and video themes.
http://www.wpzoom.com

BluChic (free and premium)
A small collection of fresh, feminine themes especially designed for women bloggers, entrepreneurs, and crafters.
http://www.bluchic.com

Press75, Dessign, ThemeTrust, and Graph Paper Press—some great places to find themes for creative websites.

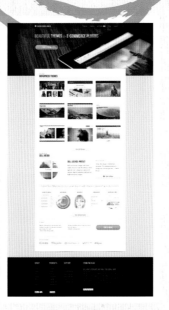

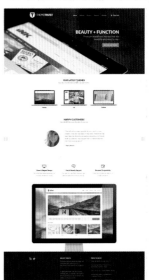

✱NOTE

Throughout this book, I have referred to themes by their name, maker, and if appropriate, marketplace. Rather than typing out a long web address from the book, search via Google. When you've got to the right website, look for the link to the theme demo so you can see the theme up and running, or go to the companion website for this book, where all the links are listed (http://www.creativepersonswebsitebuilder.com).

5 A SELECTION OF BEAUTIFUL THEMES

The following is a selection of themes that may help you get started in your quest for the ideal theme.

PORTFOLIO-STYLE THEMES

Square, EngineThemes, ThemeForest
http://themeforest.net/item/
square-responsive-wordpress-
theme/3007657

Uber, Theme Trust
http://themetrust.com/themes/
uber

Gridspace, Graph Paper Press
http://graphpaperpress.com/
themes/gridspace

Cubrick, seench, ThemeForest
http://themeforest.net/item/
cubrik-responsive-wordpress-
theme/3561412

Neue Theme, Dessign
http://www.dessign.net/neue-
theme-responsive-infinite-scroll/

Art Works, Dessign (free)
http://www.dessign.net/
art-works-responsive-
theme-free-2013/

Architekt, Dessign (free)
http://www.dessign.net/
architekt-theme

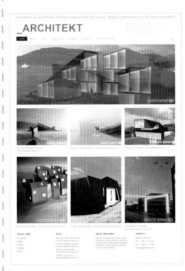

Dano, MattMao, ThemeForest
http://themeforest.net/item/
dano-multipurpose-responsive-
wordpress-theme-/3676334

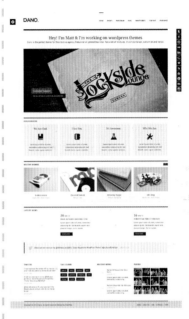

Fullscreen, Dessign
http://www.dessign.net/
fullscreen-responsive-theme

Volumes, OrmanClark, ThemeForest
http://themeforest.net/item/
volumes-responsive-portfolio-
wordpress-theme/2311911

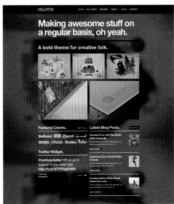

Origin, Elegant Themes
http://www.elegantthemes.com/
gallery/origin

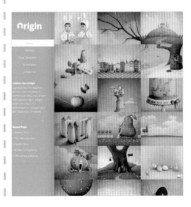

A SELECTION OF BEAUTIFUL THEMES

PHOTOGRAPHY & VIDEO THEMES

Lensa, ColorLabs (free)

http://colorlabsproject.com/
themes/lensa

Reportage, Graph Paper Press

http://graphpaperpress.com/
themes/reportage

Picks, Obox

http://www.obox-design.com//
theme.cfm/theme/picks

Sideswipe, Graph Paper Press

http://graphpaperpress.com/
themes/sideswipe

Full Frame, Graph Paper Press

http://graphpaperpress.com/
themes/full-frame

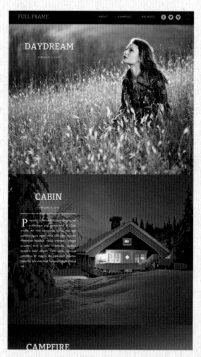

Lightbox 2, Photocrati
http://photocrati.com

Landscape Theme, StudioPress
http://my.studiopress.com/
themes/landscape

Black Label, eneaa, ThemeForest
http://themeforest.net/item/
black-label-fullscreen-video-
image-background/336949

Selecta, Obox
http://www.obox-design.com//
theme.cfm/theme/selecta

Vidley, Press75
http://press75.com/view/vidley

Gigawatt, Obox
http://www.obox-design.com//
theme.cfm/theme/gigawatt
(Also exists as an e-commerce
theme)

Synch, WPShower
http://wpshower.com/themes/
synch

49

A SELECTION OF BEAUTIFUL THEMES

MUSIC/BAND THEMES

Acoustic, cssignitervip, ThemeForest
http://themeforest.net/item/acoustic-premium-music-wordpress-theme/3750782

Music theme, Organic Themes
http://www.organicthemes.com/theme/music-theme

SoundCheck, Press75
http://press75.com/view/soundcheck

Indie Fest, Foxhound Band Themes
http://foxhoundbandthemes.com/themes/indie-fest

Live!, BrutalDesign, ThemeForest
http://themeforest.net/item/live-music-wordpress-theme/3409542

Soundstage, Mint Themes
http://mintthemes.com/themes/soundstage

ONE-PAGE THEMES

Here are some themes designed in the increasingly popular style of one-page layout, incorporating different elements at full-screen width, one following the other as the user scrolls down. They are usually highly customizable—any kind of content element (slider, portfolio, blog) can be included in the page—and can be adapted for any kind of site (personal, author, portfolio, e-commerce).

Blox, ThemeZilla

http://www.themezilla.com/themes/blox

Rythm, PixelForces, ThemeForest

http://themeforest.net/item/rythm-one-page-responsive-html5-template/3327626

SimpleKey, badjohnny, ThemeForest

http://themeforest.net/item/simplekey-onepage-portfoliowordpresstheme/3729774

A SELECTION OF BEAUTIFUL THEMES

BLOG/PHOTOBLOG/MAGAZINE STYLE THEMES

Twenty Thirteen (free)
(From WordPress Free Themes Directory, so accessible from your admin)

Sight, WPShower (free)
http://wpshower.com/themes/sight

Pure, Theme Trust
http://themetrust.com/themes/pure

Gallery, UpThemes (free)
http://upthemes.com/themes/gallery

Press, Obox
http://www.obox-design.com//theme.cfm/theme/press

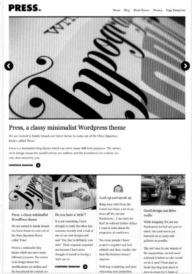

Rambles, Theme Beans, Creative Market
https://creativemarket.com/ThemeBeans/2211-Rambles-Blogging-WordPress-Theme

**Gray Lady Gray,
angiemakeswebsites,
Creative Market**
https://creativemarket.com/
angiemakeswebsites/4610-Gray-
Lady-Gray-Responsive-Wordpress

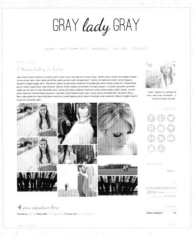

Craftiness, StudioPress
http://my.studiopress.com/
themes/craftiness

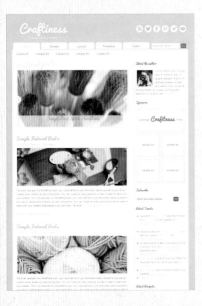

**Writer, Authentic Themes,
Creative Market**
https://creativemarket.com/
AuthenticThemes/3592-Writer-
2-Minimal-WordPress-Theme

**Cre8tive Burst, EightCrazy
Designs, StudioPress**
http://my.studiopress.com/
themes/cre8tive-burst

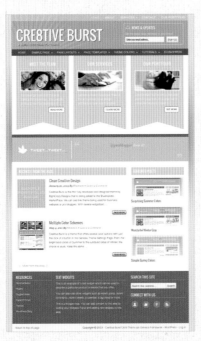

Dorothy, BluChic
http://www.bluchic.com/shop/
dorothy-theme

**Snapcase, designcrumbs,
ThemeForest**
http://themeforest.net/item/
snapcase-responsive-wordpress-
photoblog-theme/2465847

A SELECTION OF BEAUTIFUL THEMES

E-COMMERCE THEMES

Be sure to read Chapter 8 before you make your choice of e-commerce theme. If you plan to take payments on your site (now or in the future), take this into account when choosing a theme and check if the e-commerce plugins it uses are compatible with your payment gateway.

Artificer, WooThemes (free)
http://www.woothemes.com/products/artificer

Mystile, WooThemes (free)
http://www.woothemes.com/products/mystile (see Chapter 10)

CleanSale, Obox
http://www.obox-design.com//theme.cfm/theme/cleansale

Chronology, Storefront Themes
http://storefrontthemes.com/themes/storefront-chronology

Gather, Theme Trust
http://themetrust.com/themes/gather

Eureka, Colorlabs
http://colorlabsproject.com/themes/eureka

Handmade Two, Obox

http://www.obox-design.com//
theme.cfm/theme/handmade-two
(Can also be used as a blog, without
the e-commerce functionality)

HumbleShop, humblespace, ThemeForest

http://themeforest.net/item/
humbleshop-minimal-wordpress-
ecommerce-theme/3817362

Sally Store, BluChic

http://www.bluchic.com/shop/
sally-store-theme

Kinetico, XiaoThemes, ThemeForest

http://themeforest.net/item/
kinetico-responsive-wordpress-
ecommerce/2655335

Seneca, Graph Paper Press

http://graphpaperpress.com/
themes/seneca

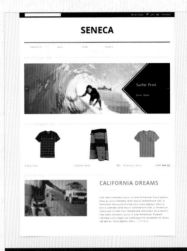

Store, Templatic

http://templatic.com/ecommerce-
themes/store

There are many more beautiful themes for each type of website, with new designs being created all the time. Check the companion website for a selection of the latest themes as they come out.

THE TECHNICAL SIDE OF THINGS

This chapter shows you the basics of WordPress. Although you will almost certainly choose a different theme, I recommend playing around with the default theme, going through the chapter page by page and trying out the different elements. That way you'll be familiar with everything when you go on to set up your chosen theme; to help you with that, you can follow the steps in the website builder roadmap on page 170.

The different elements of a WordPress site

The chances are that before reading this book, you have already visited dozens of WordPress websites without knowing they were built on WordPress, because they can look so vastly different. As we've seen in the previous chapter, there are WordPress themes for every kind of site you can imagine.

Let's look at some of the elements that can make up a WordPress website and put names to them, before we dive into the details of building your site.

As we've seen, themes exist that display work in very different ways.

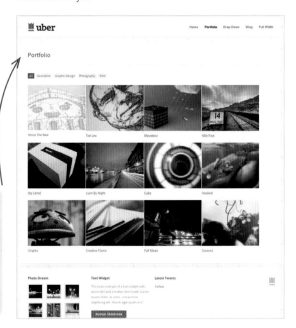

This theme, designed to showcase a graphic designer or other creative's work, comes with a built-in "filterable" portfolio—the viewer can browse the works displayed by category. There are also different layouts for blog pages and other pages on the site. (Not all themes come with different page layout options, but more recent, premium themes usually do.)

At the top we can see the logo plus the menu, also known as the navigation.

The layout of this home page is quite typical for this kind of site, with the designer's most recent projects underneath the slider, and latest blog posts and client logos underneath these.

At the bottom are widgets, known as "footer widgets." Widgets are individual elements such as recent blog posts, a photo stream, or latest tweets (widgets are explained in more detail later in this chapter).

Uber (ThemeTrust).

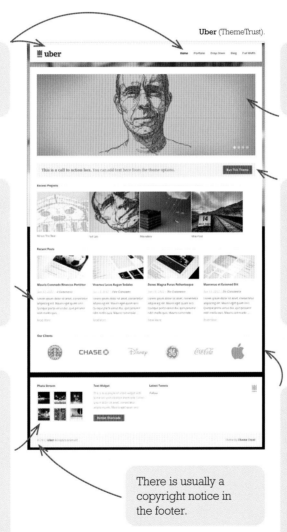

A slider, a large, rotating image on the home page, is a popular feature.

This theme has a "call to action" button (which could be used to say "Contact" instead). This isn't an integral part of WordPress, but some themes offer additional features like this.

The background of this theme is "fixed," meaning that it remains in the same place while the visitor scrolls down the page. With this theme, each page can have a different background, which is a nice, individual touch.

There is usually a copyright notice in the footer.

The different elements of a WordPress site

Sideswipe (Graph Paper Press).

This is a theme designed for blogging with a visual focus. The theme makes use of different blog post formats, with varying layouts for posts that focus on an image, a gallery of images, or a video, for example. For each blog post, we can see the date and the name of the person who created the post, plus comments visitors have left on the blog post; with this theme, we also see the number of views.

With this theme we have the images sliding in from the right.

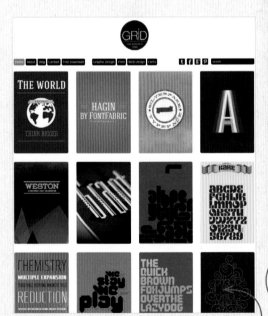

Grid (Dessign).

Here, portfolio items are displayed in a grid.

Rambles (ThemeBeans, Creative Market)

The column (to the left in this layout, although it is often on the right) is known as the "sidebar." Here, it contains the menu, and beneath the menu are widgets (Flickr and Dribbble streams—more about these in Chapter 13).

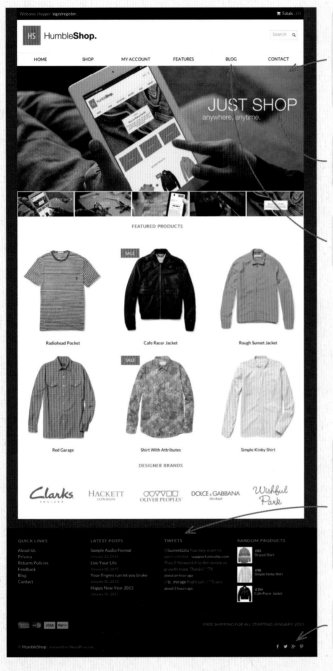

This theme is designed especially as an online store, running on the WooCommerce plugin (more details of this in Chapter 8). With this theme, you can choose to have either a slider on the home page or an "image carousel," as shown here.

With some themes, you can change the fonts using Google Fonts to make your site look unique.

As we've seen, all WordPress themes can optionally contain an integrated blog, even if this isn't the main focus of your site.

As with the portfolio theme shown on page 56, this theme has footer widgets on the home page, and sidebar widgets on the blog page. With this theme, you can choose whether to have your sidebar on the right or the left; like many other themes, it also provides a full-page option for the inner pages of the site, which has no sidebar.

Some themes come with built-in social media buttons.

HumbleShop (humblespace, ThemeForest)

Pages and posts

You can create two different types of content with a WordPress site: pages or posts.

Your pages—such as "About" and "Contact"—will be hooked up to a menu so that the visitor can access them. Your blog posts, on the other hand, will appear on the blog page of your site in a long stream, with the most recent blog posts at the top of the list.

Depending on the theme you choose, and sometimes your personal choice as well, these may be blog "excerpts"—i.e. just the beginning of the blog post, perhaps accompanied by an image, with an invitation to "Continue reading"—or the entire blog post may appear on the blog page, with the reader scrolling down to read one post after another. There will be arrows at the bottom of the page allowing the visitor to scroll backwards in time to earlier posts.

Although they appear on the site in a different way, pages and posts are managed in a virtually identical manner.

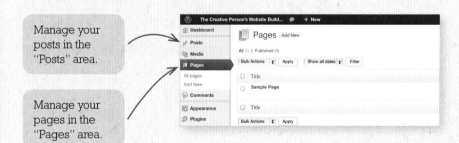

Manage your posts in the "Posts" area.

Manage your pages in the "Pages" area.

Mouse over the page or post title to edit or delete it; click "Add New" (at the top or in the left navigation) to create a new page or post.

An example of a static page

This "About" page is an example of a static page on a WordPress site.

Ulla Välk, http://www.ullavalk.nl

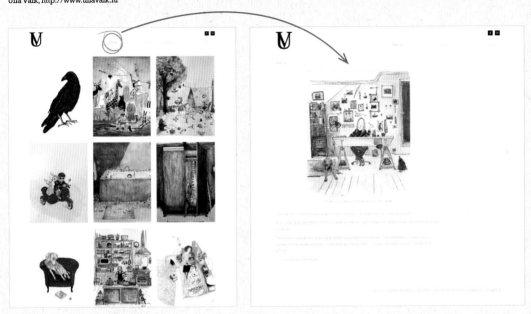

An example of a blog post

Alexa Nasland http://alexanasland.com

Here we see the blog entries, listed one after the other.

On clicking on the title of an entry, the site visitor can view the whole blog post.

Putting what you want on the home page

By default, when you set up a site with WordPress your blog posts appear on the home page.

If you want to have something else appearing on the home page—your own introductory text, for example—you can easily change this around and put your blog posts in a separate blog area on the site. Create, and save, a page entitled "Home" within the "Pages" area, and another page entitled "Blog" (or whatever you want to call your blog on your site). Leave your blog page empty, as your posts will automatically fill it; you can come back and fill in your home page content afterwards.

Go to Settings > Reading and alter the settings as shown; when you're done, click the blue button to save the change.

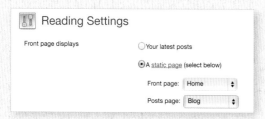

HOME PAGE SETUP WITH DIFFERENT THEMES

For some themes, you will not have to create a home page, as the theme will automatically "draw in" material to create the page from your blog posts and your portfolio. Some themes will also give you a special blog page layout that you will assign to the blog page (see page 85), meaning you don't need to make the change in the Settings area. Whether or not this is the case will depend on the theme, and will be explained in the theme documentation.

The WordPress page and post editor

Many of the buttons on the page and post editing screen will be familiar to you from using Word and other text-editing programs. Here we look at some of the buttons that will not be so obvious to you.

This is the "kitchen sink" button—when you click on it, it reveals a row of other buttons, as shown in the other screenshot. (The idea is to help you keep your screen as uncluttered as possible.)

Write your title here.

Here is where you add images and audio to the page or post.

Write your page text here.

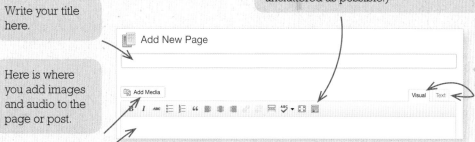

You will usually be writing in the "Visual" mode. If needed, you can paste code into the page by clicking on the "Text" tab.

Add a link with this button (select the link text first; there is an option to have the link open in another window if you want).

Create a "continue reading" break (only for blog posts, not for pages).

Select the style of your text. "Paragraph" for normal text and various sized headings for impact and readability.

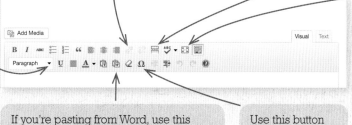

Click for a "no-distractions" writing mode.

If you're pasting from Word, use this button and paste into the window that opens to prevent unnecessary formatting being copied along with your words. This is useful for people who like to prepare their blog posts outside of WordPress.

Use this button for symbols and accents.

Options for creating pages

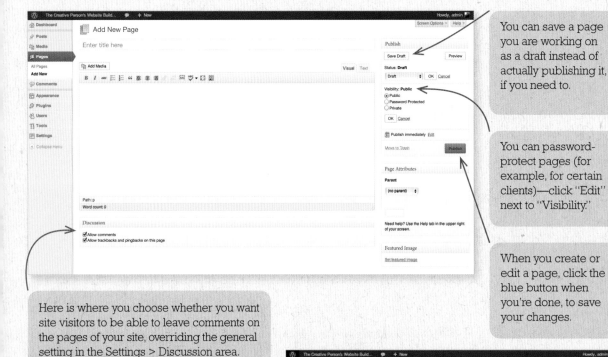

You can save a page you are working on as a draft instead of actually publishing it, if you need to.

You can password-protect pages (for example, for certain clients)—click "Edit" next to "Visibility."

When you create or edit a page, click the blue button when you're done, to save your changes.

Here is where you choose whether you want site visitors to be able to leave comments on the pages of your site, overriding the general setting in the Settings > Discussion area. Note: if you can't see this box underneath the text box, click the gray "Screen Options" tab at the top right of your screen, then select the checkbox labeled "Discussions."

✦ SORT OUT YOUR PERMALINKS

The default for WordPress is to save your pages and posts with a numerical ID, for example http://www.yourdomain.com/?page_id=16. This format not only looks ugly when you have to quote a web address on your site, but it doesn't help the search engines understand your website content either.

Go to Settings > Permalinks and choose the "Post name" option; save by clicking the blue button. Your pages and posts will now have more sensible-looking web addresses, named after the title you give to your page or your post.

Options for creating posts

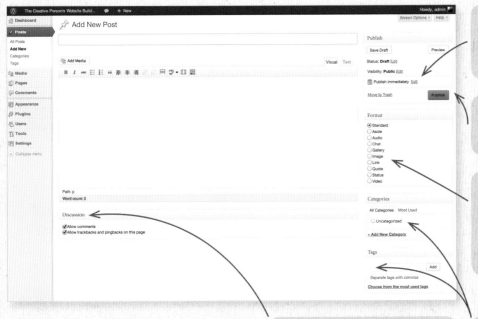

You can schedule your posts for publication ahead of time.

Click the blue button to publish a post or save changes.

Choose the blog post format for the post you're writing (you won't have this option with all themes).

Enable or disable comments on the post (overriding your overall setting in the Settings > Discussion area)

Assign tags to your post and file it in a category (see left).

Categories and Tags

Categories act as a kind of filing system for blog posts. You can create a list of categories for your sidebar so your visitors can read posts by topic of interest. Create categories either directly from the box on the right or in the Posts > Categories area. Tags are like keywords you can attach to a post. As an example, a blog post might be filed under "Exhibitions," whereas keywords might be the artists' names, their style, their period, names of the works displayed, etc.

If you don't specify a category for a post, it will automatically be filed under "Uncategorized." This is a rather clumsy and unprofessional label, so it's a good idea to change the name of the default post category to something like "News" or even simply "Blog Posts" (you can change a category name under Posts > Categories > Edit).

FEATURED IMAGES

Not all themes display featured images for blog posts, but often a blog post will be shown with a prominent image next to its title or at the top of the post; these images need to be attached to the post via the "Featured Image" pane at the bottom right of your editing screen, just underneath the "Tags" pane.

Menus

Until you create a menu and assign your pages to it, pages will appear on the site in the order in which you create them. Some themes have multiple menus, for example in addition to the main navigation bar, there may be a small menu that appears at the top or the bottom of the page. Manage your menu(s) from the Appearance > Menus area.

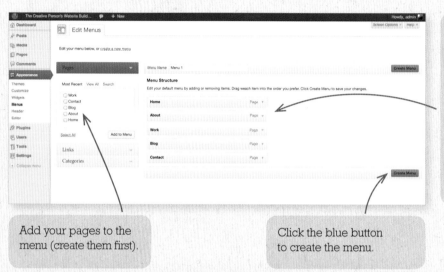

Rearrange the pages in the menu by dragging them with your mouse. You can create sub-menu items by indenting them (just drag them to the right). To remove a page from the menu, click on the small gray triangle to the right of the page title, then click on the red "Remove" link.

Add your pages to the menu (create them first).

Click the blue button to create the menu.

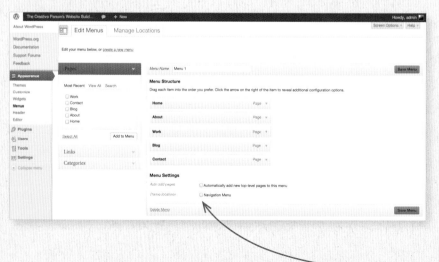

Once you've created the menu, you need to assign it to the right menu position on your page. This can also be done from within the "Manage Locations" tab, which has now become visible. (A simple theme will probably have only one menu location, but more complicated themes will have additional ones.) Save the change and you'll be able to see your menu on your site, with the pages in the order you've chosen.

BLOG CATEGORIES AND OTHER LINKS

You can add blog categories and external links to the menu as well. An external link is useful if you have another website you want to link to from the site you are creating, for example.

✳ TIP

If you want a custom link to open in a new window, click "Screen Options" at the top right of your screen and select the "Link Target" checkbox. Now click on the triangle to the right of your menu item so that the options pane opens, and select the checkbox next to "Open link in a new window/tab."

To create a heading on a menu

Sometimes you may want to create an item on a menu that functions as a title for sub-menu items underneath it (i.e. you don't actually want it to be a clickable link). To do this, create a link within the "Links" pane, with the heading name you want to see on the menu, but instead of giving it a URL (web address), type "#" into the URL field. Add it to the menu, drag its sub-menu items into the right place, and save it. You'll now have a heading for those sub-menu items.

To change the title of a menu item

Sometimes you don't necessarily want the title of the page to be the same as the label for the page in the menu—for example, a long page title will not be practical for the menu. To change the label, click the triangle to the right of the menu item so that the options pane appears, then change the "Navigation Label" to the shorter label you'd like to see in the menu.

This can also be useful for the home page, depending on the theme you're using. It's most likely that you won't want "Home" written prominently on your home page, in the way that other page titles are displayed. So, change the title on the page itself to something that you do want to see written on the home page, then come back here and change the navigation label to "Home."

Sidebars and widgets

As we've seen, widgets are the elements that go in the columns on the right or the left of your website pages (the sidebars) as well as sometimes in the footer area. Widgets are managed from within the Appearance > Widgets area.

These are the widgets that come with WordPress. Just drag them into the areas to the right of the screen where you want them to appear.

These are the ones that WordPress puts in for you automatically. You can safely drag them out of the sidebar area and start afresh.

For the default theme, the widgets that you put in this area will appear in the footer.

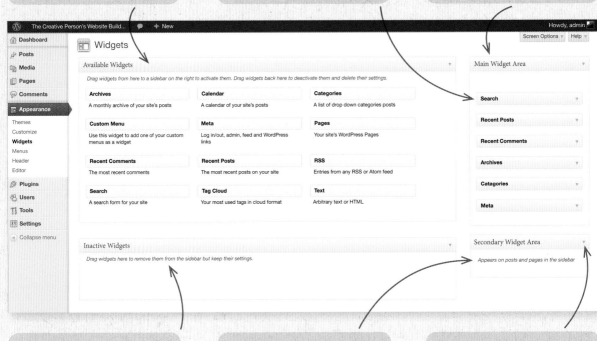

You can store configured widgets here, which will save their settings if you think you may want to use them again later.

For the default theme, widgets that you put here will appear on the right-hand side of your static pages and individual blog posts.

Click on the small triangle to the right to open or close each sidebar pane. Individual widgets can be opened in the same way to configure their settings.

THE MOST USEFUL STANDARD WORDPRESS WIDGETS

Archives and Calendar

These are very useful for your blog pages as they enable your readers to navigate around your site chronologically; if you don't implement one of these navigational aids, your readers won't have an easy way to move around your blog and read your past posts. With the Archives widget, you can choose to display a month-by-month drop-down menu—this is a good space-saver in the sidebar once you have a large amount of blog content.

Categories and Tag Cloud

These allow your readers to find the blog posts that interest them by topic or keyword.

Recent Posts

If your blog is a major feature of your site, it may be a nice touch to add the Recent Posts widget as it will add interest to the static pages of your site. But if you don't post often, don't add this widget, as it will only serve to highlight the fact that you are not very active on your blog.

Search

An on-site search is handy for your readers if you have a lot of content on your site; I wouldn't implement it if your site is small.

Custom Menu

This is useful if you have pages on your site you want to make accessible, but don't want to add to the main menu—with this widget you can display a mini-menu in the sidebar linking to these pages. Create a new menu in the Menus area (as we saw on the previous page) and add these pages to it, then come back to the Widgets page and add the new menu to the sidebar with the Custom Menu widget.

Text

If you have a text message you want to put in the footer or sidebar, this is how you can include it. For example, some people put a short "about" text in their footer so it is visible on every page, or include their telephone number or contact details so these are always easily accessible for site visitors. In addition, if you ever need to add a snippet of HTML code to you sidebar or footer, you can simply paste it into the Text widget. (One example of when you might need to do this is if you want to add a social media badge, but there are many alternative ways of doing this, as we'll see in Chapter 13).

Dozens more widgets become available once you start installing plugins (see the next chapter).

RENAMING WIDGETS
It's easy and often makes sense to retitle widgets.

The best way of deciding which widgets you want to use is simply to try them out.

Adding images

Images are added to pages and posts using the "Add Media" button.

Click your mouse where you want the image to appear and click "Add Media."

You can either drag and drop images into the upload area, or select them from your computer. Multiple images can be uploaded at the same time.

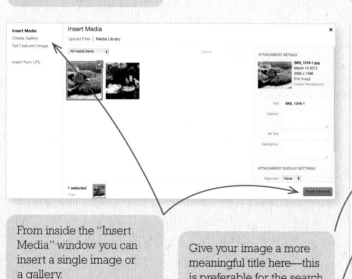

From inside the "Insert Media" window you can insert a single image or a gallery.

Give your image a more meaningful title here—this is preferable for the search engines.

Captions are optional.

You can copy your title again here. Nobody will see this field but it is useful for the search engines. You don't have to write anything in the "Description" field—it's only for you.

Choose the alignment of the image.

Choose whether to link the image to a web address, to a larger version of the image within a browser window, a page with the image in it, or not to link it at all (the most common option).

Choose the approximate size at which you want to display the image—you can fine-tune it later, but choose a larger size as you can only reduce it.

WORKING WITH IMAGES FOR YOUR SITE

✳ Images for websites need to be in .jpg (.jpeg), .png, or .gif format.

✳ You don't need to resize your images before uploading them, as WordPress will do this for you, but there is a maximum file upload size that varies according to your host (with DreamHost this is 7MB). You can reduce the size of your image files using any graphics program (or Pixlr.com).

✳ If your hosting package offers you limited storage space, do reduce the size of your images before you upload them, as large images will use up space unnecessarily—especially digital photos, which can be huge.

✳ Images for the web are measured in pixels. To give you an idea, the width of the text area on a page using the Twenty Thirteen theme is 590 pixels. You will rarely need to upload an image larger than 1000 px in width (unless, of course, it's a full-width background image).

✳ You can easily resize images to specific pixel measurements, if needed, using Photoshop or Photoshop Elements. Pixels are the default unit of measurement when using Pixlr.com.

✳ If you need to reduce the file size of an image to use as a background, save it at a lower quality. You won't want to have a background image larger than 1MB in size as it'll take too long to load.

Adding images

To fine-tune the size of an image, click on it and then adjust the size inside the window.

To edit an image or a gallery, click on it, and then click on the image button.

You can re-order the images or change the gallery settings inside the "Edit Gallery" window. Individual images can be captioned from inside here as well.

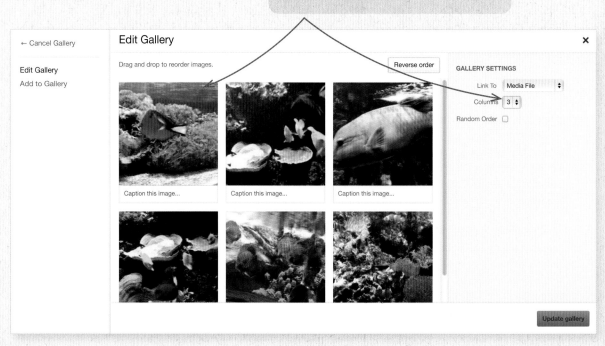

* TIP

The Jetpack plugin (see Chapter 7, page 91) gives you some great layout options for galleries. Many premium themes also have special gallery layouts.

MARGINS AROUND IMAGES

If you have set an image to align to one side with text "wrapping" around it, you may need to create some blank space to one side of the image so that the text doesn't sit too close. To do this (in this case for a right-aligned image), click on the "Advanced Settings" tab (visible in the screengrab opposite). Type "20" in the "Horizontal space" field, click anywhere inside the image editing window, and remove "margin-right: 20px;" from the "Styles" box. Click the "Update" button, and then the blue button to update the page, and you now have a small blank margin to the left of the image.

The WordPress gallery looks like this.

Gallery

This is an example of a gallery.

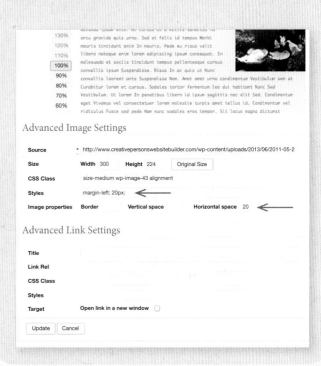

Editing images within the media library

It's sometimes useful to be able to edit images right inside WordPress. This is particularly useful for gallery thumbnails; if the area automatically selected for the thumbnail doesn't look good, you can choose the area to be displayed.

Images can be edited from within the Media Library. Mouse over the space below the title, and a row of links will appear—click on "Edit."

You can also access the editing area via the "Insert Media" window.

Here is where you find the URL (web address) for an uploaded image, if you should need it.

WordPress has a neat trick for helping you select a square area for a thumbnail (see the box to the left).

CREATING A THUMBNAIL

To create a new thumbnail, select a roughly square area of the image using your mouse. Type "1" in both "Aspect Ratio" fields and key "Enter;" your selection will now be perfectly square. Move it to the right place, then click the "Crop" icon. Select "Thumbnail" where it says "Apply changes to," click "Save," and then "Update." Click "Refresh" back in the "Edit Gallery" window (if you were working within the window) and update the gallery.

As well as images, you can also add video and audio files to your Media Library, but as we will see over the next pages and in Chapter 7, there are other options for incorporating these into your site.

Embedding audio, video, and other content

Video

As we've said, you can import video directly to your Media Library, but there are a number of reasons why it's usually a better idea to use a third-party video sharing site, such as YouTube or Vimeo, and embed the video.

✳ There will be a limit on the size of your video uploads, depending on your host. Most videos will be much larger than the size limit.

✳ It would use a lot of bandwidth to run it off your own host.

✳ The display is less elegant—it opens on another page, rather than being embedded seamlessly inside your page content.

✳ The video sharing sites optimize the videos for an optimum viewing experience.

✳ In addition, the large audience on the video sharing sites may bring you additional traffic.

WordPress makes it super-easy to embed videos from video sharing sites. Just copy the URL of the video you want to embed, paste it into the page or post editor, save the page, and you'll find the material embedded into your site.

> "Embedding" simply means incorporating material into your site so that it blends seamlessly, when it's actually hosted somewhere else. WordPress has a neat system which lets you embed certain types of content straight into your site just by adding the web address of the material you want to embed.

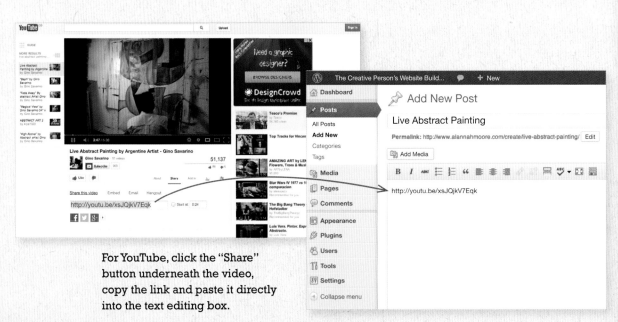

For YouTube, click the "Share" button underneath the video, copy the link and paste it directly into the text editing box.

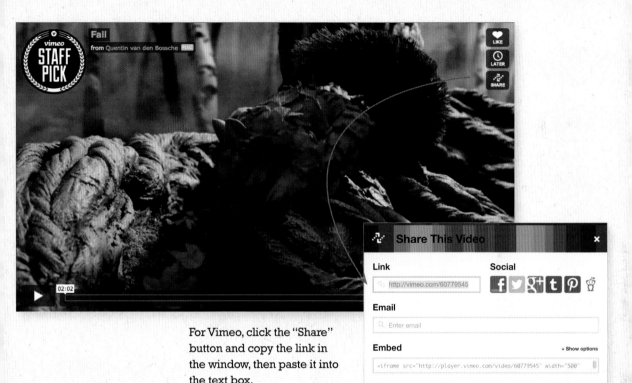

For Vimeo, click the "Share" button and copy the link in the window, then paste it into the text box.

YOU CAN EMBED THE FOLLOWING VIDEO SERVICES IN THE SAME WAY:

Dailymotion
blip.tv
Flickr (videos and images)
Photobucket (videos and images)
Viddler
Hulu
Revision3
Qik

YOU TUBE VS. VIMEO—WHICH VIDEO SHARING SITE TO USE?

* YouTube has a larger audience which increases the odds of your video being seen on the YouTube site itself.

* Vimeo embeds look cleaner.

* Your video is limited to 15 minutes on YouTube, but is unlimited on Vimeo.

* Vimeo's free account limits your upload to 500MB, 2GB a month; 2GB on YouTube with no monthly limit.

Embedding audio, video, and other content

The Vimeo embed looks cleaner than the YouTube embed.

The upload size is larger on YouTube with no monthly limit.

Audio

As with video, you can upload audio to your website via the Media Library, but it doesn't give a great result—the audio player will be viewed in a separate page and not streamlined with the rest of your content.

There are several solutions, one of which is to use SoundCloud, a third-party audio sharing platform (thereby removing any worry about file size), or by using a plugin—we'll see some of these in Chapter 7.

OTHER CONTENT YOU CAN EMBED FROM THIRD-PARTY SITES

WordPress can also automatically embed material from the following:

SmugMug
Instagram
Scribd
Polldaddy
FunnyOrDie.com
Twitter
SlideShare

You can embed directly from SoundCloud by pasting the web address into your text editing area, as shown, or you can use a plugin, which allows you more control over how your material appears.

There are plenty of other ways to incorporate videos, images, audio, and social media into your website. We'll look at these in the next chapter and in Chapter 13.

How to install a theme

As you'll have seen, when you first set up WordPress, the default theme, Twenty Thirteen, will be installed on your site. Changing themes is easy. It's simply a matter of accessing the theme you want to use from the Free Themes Directory (http://wordpress.org/extend/themes), or uploading one from a separate source.

Installing a theme from the WordPress Free Themes Directory

If you're going to use a theme that you've found in the WordPress Free Themes Directory, it'll take just a few clicks to install your theme.

You will find that some themes come already installed with WordPress. (Which themes you already have installed will depend on your web host.)

If you navigate to Appearance > Themes, you'll see the themes that are already installed. You can test out how these would look, without actually going live with one, by clicking on them.

If the theme you've chosen isn't already installed, but you found it in the WordPress Free Themes Directory, click on the "Install Themes" tab towards the top of the screen.

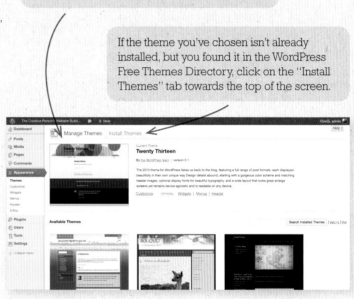

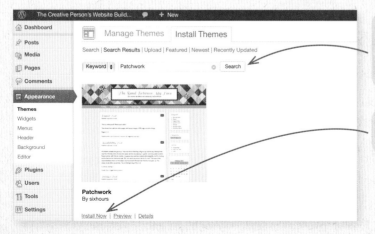

You can search for your chosen theme by name (or browse the Directory by clicking on the various links and search options available).

Click "Install Now," or preview how it looks.

Installing a theme from another source

If you're installing a theme from elsewhere, whether free or premium, you'll need to download a zip file from the theme provider.

If you work on a Mac, it is likely that your computer will unzip the zip file for you. You actually need the theme to be in zipped format to upload it, so you'll need to zip it up again. Right click on the folder, and choose "Compress."

To upload your theme, go to Appearance > Themes > Install Themes > Upload.

UPLOADING THE CORRECT FILES

It's common for some theme providers to zip their documentation together with the theme for you to download. You don't need to upload all of this—if you do, your theme won't work properly. So, before uploading, unzip the file you downloaded (if it hasn't unzipped itself)—this you do by double-clicking on it—and check inside. If there is a second zip file inside, that will be the file you need to upload. If not, upload the original zipped version of the folder.

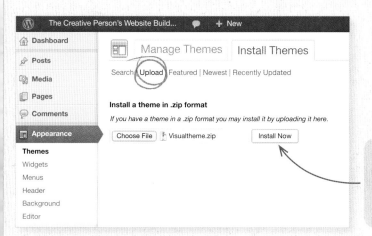

Click "Choose File," navigate to the zip file, and click "Install Now." When it's installed, click "Activate."

Your new theme is now ready for customization.

EXTENDING WORDPRESS WITH PLUGINS

We've mentioned plugins in passing, but we should clarify what exactly they are since they will be hugely important for you in the development of your site. Plugins are little bits of code developed by independent programmers that you can add to your website to enhance its functionality, making it do pretty much anything you want it to do. For example, you can add a plugin that adds an events manager to your site, so that you can easily list exhibitions, book signings, gigs, or other events you want to show on your website.

For the most part, plugins for WordPress are free, though you will find that if you want to add something really fancy, you might have to pay for it.

To add a plugin to your site
Browse the Wordpress Plugin Directory (see the box opposite) to identify the plugin you want to install.

When you've found what you're looking for, navigate to the Plugins > Add New area of your administration.

Use the search box to locate a plugin by name.

> * **TIP**
> The easiest way to find out if a plugin will suit your needs is to install it, activate it, and try it out. If it isn't right for what you need, deactivate it and delete it; keeping plugins installed that you aren't using will only slow down your site.

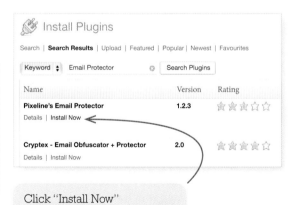

Click "Install Now" and then "Activate."

FINDING PLUGINS

In order to find a plugin that will add a particular function to your website, head over to the Wordpress Plugin Directory (http://wordpress.org/extend/plugins) and search by category or keyword. The plugin directory is tied in with your WordPress admin area, so once you've found what you're looking for, it's really easy to install and activate the new plugin.

You can also search and look at the details of plugins from inside your administration,

but if you look at the listings in the directory instead, you can see at a glance if a plugin is updated for the latest version of WordPress, and how many other people have downloaded it, which is a good indication of how useful it is.

You can also Google what you are looking for, as your search results may return an article comparing the different options available to you, which will certainly save you some time (though do check that the article is very recent).

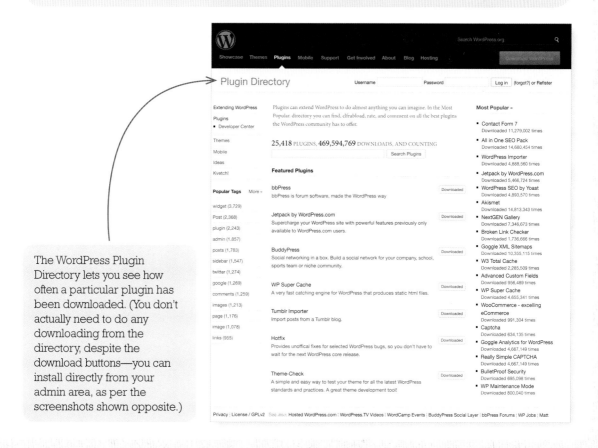

The WordPress Plugin Directory lets you see how often a particular plugin has been downloaded. (You don't actually need to do any downloading from the directory, despite the download buttons—you can install directly from your admin area, as per the screenshots shown opposite.)

Essential plugins

There are certain plugins you can't do without. The following are ones I install every time I create a website, and regard them as essential tools.

Akismet

Akismet is a magnificently effective spam-blocker that stops you being drowned in a torrent of comment spam left by robots on your site. It isn't free for any kind of professional site, but at $5 a month, it's certainly worth it—in fact, it's regarded as so necessary that it comes already installed with WordPress. All you need to do is activate it and sign up for an Akismet key (which functions as a password).

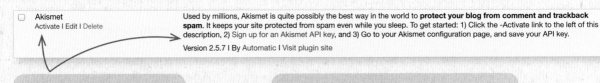

Activate Akismet on the "Installed Plugins" page, then click the "Sign up" link.

Sign up for an Akismet account. This means getting a username and password for WordPress.com (or using your existing login, should you already have an account), but you won't actually be using their blogging system. Just follow the steps and copy the "key" they give you.

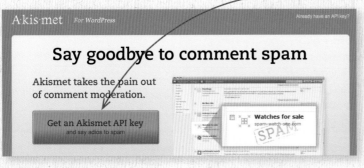

Then come back to your admin area and go to Plugins > Akismet Settings. Click "I already have a key," paste in your key, and click the "Save Changes" button.

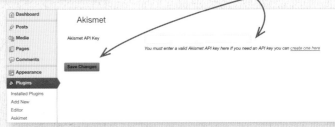

Your Jetpack is almost ready - A connection to WordPress.com is needed to enable features like Stats, Contact Forms and Subscriptions. Connect now to get fueled up!

Connect to WordPress.com

Jetpack

Jetpack is an ever-growing collection of tools that were until recently only available for WordPress.com users, but now are also available if you're using self-hosted WordPress. Go to Plugins > Installed Plugins and click the "Activate" link under "Jetpack;" click the green button that appears at the top of the screen as shown above. Since you've just signed up with WordPress.com to set up Akismet, all you need to do is click the "Authorize Jetpack" button.

Connect to WordPress.com

Once you've connected with WordPress.com and "authorized" Jetpack, navigate to the Jetpack area of the admin to experiment with the fun and useful options you now have access to (see over the page).

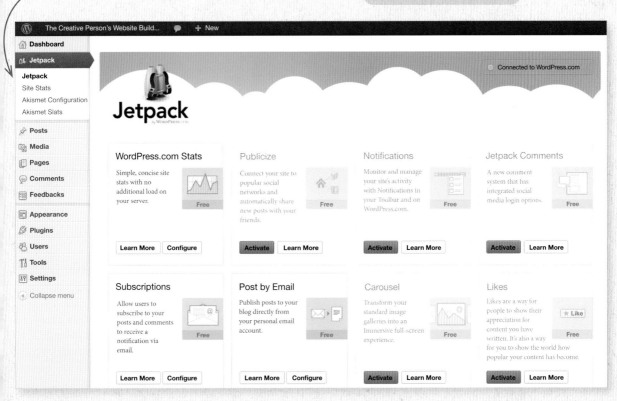

Essential plugins

The collection of tools in the Jetpack suite grows all the time, but at the time of writing, I find the most useful to be:

* Subscriptions—a handy way to allow readers to subscribe to your blog and receive your latest blog posts by email.
* Contact Form—many themes have a special contact form page layout that you'll choose to use, but if your theme doesn't, you'll want to add a form to your site so that people can contact you easily. (Your messages will be sent to you by email, and you can also access them via the "Feedbacks" area within the admin that appears once Jetpack is connected to WordPress.)
* Carousel—displays your WordPress galleries (when a thumbnail is clicked on) as a full-screen dark or light slideshow (see the box opposite).
* Tiled Galleries—makes your regular WordPress galleries look beautiful with a stylish mosaic layout (see opposite).
* Extra Sidebar Widgets—easy ways to add Twitter tweets, a Facebook Like button (plus faces if you like; see page 148) and images to your sidebar widgets.
* Infinite Scroll—turns your blog page into one very, very long, scrollable page (so your visitors can read continuously).
* Post by Email—creates a special email address for you to use to post to your blog by email; great for posting on the move (see page 163).
* Additional tools for promoting your site via social media, which will be explained further in Chapter 13.

Having set up the "Subscriptions" form for your blog, you can see who's signed up by going to Jetpack > Site Stats, scrolling down to the Subscriptions pane at the bottom, and clicking "Blog."

SETTING UP YOUR CONTACT FORM

The Jetpack contact form allows you to add whatever fields you need to the form. You may want to remove the "Website" field that it comes with, as it's by no means certain that everyone writing to you will have a website. I also always change the "Comment" label to "Message" as it seems more appropriate. Because you can customize the form, you can use it for any other feedback forms you need anywhere else on your site.

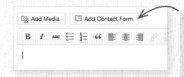

Add a form to a page by clicking this icon (once Jetpack is activated).

MAKE YOUR GALLERIES SLICKER

If you are using a specially created portfolio theme, or any other type of theme with a visual focus, it will certainly come with its own nicely formatted gallery. But if you are using a simpler theme, implementing the Jetpack gallery features will make your galleries look immeasurably more slick than using the standard WordPress gallery—see opposite.

USING JETPACK WITH YOUR WORDPRESS GALLERY

The way the regular WordPress gallery is displayed depends on the theme you're using, but it usually looks very simple.

With the Jetpack Carousel activated, when site visitors click on a gallery thumbnail, they get to cycle through this impressive full-screen slideshow that comes in dark or light versions.

The WordPress gallery looks much more interesting and stylish with the Jetpack Tiled Galleries feature activated.

And these are the circles.

This is the square tile option.

Essential plugins

Pixeline's Email Protector

If you've set up a contact form on your site, it's also a good idea to show your site visitors your real email address. There are two reasons for this: firstly, it gives your visitors another way of contacting you, as a back-up. Secondly, showing your real email address adds to your credibility, and provides an alternative for people who are wary about submitting their email addresses via a form on the internet.

However, exposing your email address on your website will make you vulnerable to spam, so you need to protect it—which is where this plugin comes in. Search for "Email Protector," install and activate it. You can now safely include your email address on your website without fear of it being "harvested" by spam robots. Just type in the email address and it will automatically become a live link.

All in One SEO Pack

Some premium themes have built-in search engine optimization tools, however, if not, you'll need this one to prepare your website for the search engines. Having installed it as usual via the Plugins area, go to the "All in One SEO" section that is now visible in your navigation. To configure it there are three fields in the "Home Page Settings" pane that you must fill in (you can also optionally add settings for each page on your site—this you do at the bottom of every individual page editing screen in your admin area). We'll explain how to fill in these three essential fields on page 142 as you need some background on search engines to do this.

Contact Form 7

There may be a time when you need an alternative contact form. It may be that the contact page that comes with a premium theme doesn't suit your purposes, or there may be some reason—such as a conflict—causing your Jetpack contact form not to work. That's where Contact Form 7 comes in . . . the most-downloaded form plugin available. It's easily configurable to include whatever fields you need. Make sure you test your contact form once you've installed it to make sure you receive your messages (by email). Install it, as usual, by searching from within the Plugins area of the admin.

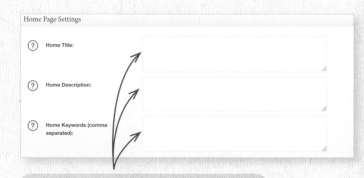

Fill in these three fields as per the guidelines on page 142. (You don't need to alter the other settings.)

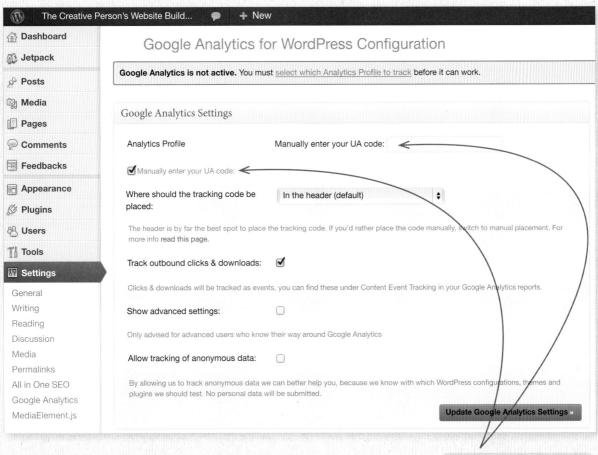

Google Analytics for WordPress

Jetpack gives you some website traffic stats in the Jetpack > Site Stats area, but if you want to track your visitors in a more complex way, you'll undoubtedly want to sign up for Google Analytics.

You'll need a Google account to sign up for Google Analytics; when you've done this, add your website address as an "account" within Google Analytics, and copy your tracking ID, which will begin with "UA." Search for, install, and activate the "Google Analytics for WordPress" plugin; the easiest way to set it up is to manually paste in your tracking ID as shown above.

Paste in your tracking code here.

More useful plugins to add functionality your site

NextGEN Gallery

A hugely popular gallery plugin that allows you, among other features, to group your galleries into albums. If you have a large amount of images you want to display, and you're not using a theme with a specific gallery system of its own, you'll certainly want to investigate this one. (It also lets you watermark your images).

NextGen gives you multiple options for organizing and displaying your galleries.

Vimeography (free and premium)

If you have a number of videos to display on your site—and you use Vimeo to host them—you can use this plugin to create beautifully laid-out custom video galleries. See http://vimeography.com for some of the more sophisticated options you can purchase; you can install the free version via the Plugins area of your admin.

If you don't use a theme for video, Vimeography is the slickest option around.

SlideDeck 2 (free and premium)

If the theme you're using doesn't have a slider incorporated in it, you may want to add one to your home page or to your other pages and posts. This plugin allows you to create the most amazing sliders with dozens of different looks, which can be populated with images, video, Twitter, Pinterest, or Flickr content, or pretty much anything you like. The "lite" version can be installed from your Plugins area—visit http://www.slidedeck.com to be inspired by what you can do with the premium option.

Choose from dozens of different looks for your slider with SlideDeck 2.

The Slideshow plugin has been used here to fill the main area of this site's home page with large-size graphics (http://www.atlantastreetsalive.com).

Slideshow

If you don't want quite as jazzy a slideshow, you can install something simpler. There are in fact dozens of slideshow plugins you can choose from, but one I use often is titled simply "Slideshow"—the developer's name, to distinguish it from the others, is StefanBoonstra. Once you've set up a slideshow, you can add it to a page either by copying and pasting the code for the new slideshow (shown on the page where you've set it up), or by adding a widget to your sidebar—a new widget called "Slideshow widget" will appear when you install the plugin. You will need your images to be the same size—you can either do this outside WordPress, or create your slideshow, then resize them from within the Media Library.

Portfolio Slideshow

A clean and simple-looking thumbnail slideshow. Install the plugin as usual via the Plugins area. The size of the porfolio is configured within the Settings > Portfolio Slideshow area; you can upload images to a page or post in a new "Portfolio Slideshow" pane now visible beneath the text editing area. Copy the shortcode as shown in the pane ([portfolio_slideshow id=xx]) and paste it into the page or post where you want it to appear.

More useful plugins to add functionality your site

SoundCloud is Gold

As we saw back in the last chapter, you can embed a SoundCloud track directly into a page or a post by simply pasting in the URL of the track. But if you install the SoundCloud is Gold plugin, you can customize the appearance of your tracks and sets (albums/playlists), which looks a whole lot more professional. It's also great for letting your visitors listen to podcasts directly from your site.

Once you've installed and activated the plugin, configure your settings and then add a player to the page via the "Soundcloud is Gold" tab of the Media Uploader.

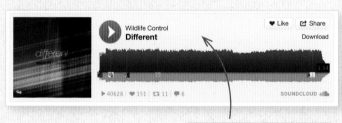

This is what a regular SoundCloud embed looks like.

SoundCloud is a wonderful way of sharing your music or your audio files, with a 2GB upload limit and 2 hours upload time/100 downloads for free account users, and premium accounts beginning at just €3 per month (approx. $4 per month).

This is what an "artwork" embed using the SoundCloud is Gold plugin looks like—it looks great for podcasts as well. (There is a "Buy" button that goes to iTunes when the image is moused over.)

A separate plugin, the Stratus SoundCloud plugin, lets you display a player strip at the top or the bottom of your website. (Search "Stratus" in the WordPress Plugin Directory.)

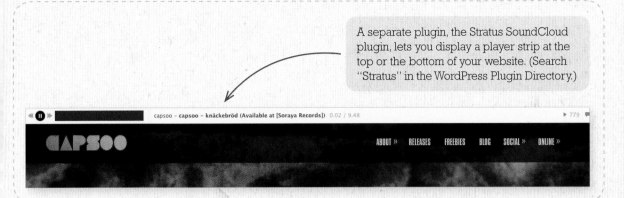

HTML5 jQuery Audio Player (free and premium)

A very nice looking way of allowing your visitors to listen to tracks grouped into playlists from your site—you can assign an image for each track, as well as adding "Buy" (linking to Bandcamp, iTunes, wherever you like) or "Download" buttons.

If you aren't using a special music theme, this is a great way to let your visitors listen to, download, or buy your music.

 TIP

If you want to link directly to the iTunes Store, go to the link maker to generate your link: https://itunes.apple.com/linkmaker

More useful plugins to add functionality your site

MediaElement.js—HTML5 Video & Audio Player

As we saw back in the last chapter, while it's easy to add video to your site where the result looks great, adding audio to WordPress in the basic way isn't quite as satisfactory. Themes created specifically for music will include a way to feature excerpts of music more elegantly, as will the JQuery Audio Player on the previous page, but if you just want to display an audio file with the simplest possible player, a plugin that comes bundled with WordPress, MediaElement. js, will do the trick. (It supports MP4, OGG, WebM, WMV, MP3, WAV, and WMA files.)

First, upload your file to the Media Library and copy its URL (web address). Activate the MediaElement.js plugin in the Plugins area. Type a shortcode directly into the text editing area of the page or post to which you want to add the audio, as follows:

[audio src="the URL of your audio file as shown in the media library"]

The player will appear on your web page like this:

If you use Bandcamp or ReverbNation, you can paste the "embed" code from their website into the "Text" pane of your page or post editor (or into a "Text" widget) for the player to display on your site, complete with "buy" link. (You don't need to install a plugin.)

USING THE PLUGIN FOR VIDEO

As its name suggests, the plugin works with video as well, and displays it in a very neat and minimal style. However, it's very likely you will be constrained by your file size upload limit, which will mean that for all but very short videos, YouTube or Vimeo will be a preferable option. (If you do want to display a video with the plugin, use the same code as to the left, just replace "audio" with "video.")

Bandcamp is an online music store for independent musicians (sign-up is free). ReverbNation provides a central location for digital distribution and online promotion.

Events Manager

There are a number of event management plugins available, as you will see if you search the Plugins Directory—the one I use most often is called simply "Events Manager." It's an efficient way of integrating an events calendar into your site, allowing you to show events (complete with images and Google Maps) and calendars on your pages and in your sidebars. Visitors can book to attend directly from the site, and the premium version allows you to integrate with PayPal and Authorize.net to accept payments as well.

Etsy Shop

If you sell via Etsy, it makes sense to include your items directly on your website so that people can see them without having to click onto your Etsy shop. With the Etsy Shop plugin, a simple shortcode makes this easy. (Your customers will buy through Etsy, just as normal.)

Install and activate the plugin as usual, then navigate to Settings > Etsy Shop. Follow the link to create an Etsy API "key" (which functions like a password). This looks complicated but it isn't—you fill in the form as if you are a developer but you aren't going to develop anything—you just need the key, and so you don't need to be precise about the information you provide. Copy the string of numbers next to where it says "Keystring," use your browser's "back" button to go back to the Etsy Shop Settings page, and paste the numbers into the box before saving. Type [etsy-include= your-etsy-shop-name;your-etsy-shop-section-id] into your page where you want the shop section to appear. You can see the shop section id—a number—in the browser address bar, for example: [etsy-include=CeramicaBotanica;6506588]. Your shop section will now be displayed as shown here.

Ceramic Bowls

Ceramic bowl/ grass gre...
Available $50.00 USD

Serving Bowl Lush Green
Available $125.00 USD

Made to Order Large 12 in...
Available $150.00 USD

Ceramic serving bowl/ Sky...
Available $50.00 USD

Ceramic serving bowl, Sal...
Available $125.00 USD

Squircle Serving Bowl in...
Available $75.00 USD

Steel Grey Mod Pattern Se...
Available $125.00 USD

cup or small bowl Mediter...
Available $25.00 USD

Ceramic Serving bowl squi...
Available $75.00 USD

Peppermint red candy bow...
Available $42.00 USD

Large Serving Bowl - Nigh...
Available $150.00 USD

Chartreuse X & O bowl---...
Available $25.00 USD

Displaying your products right on your website is much more inviting than having your visitors click an "Etsy" button (Susan Rodriguez Pottery, http://www.etsy.com/shop/CeramicaBotanica).

EXAMPLE SETUP 1:
A PORTFOLIO/BLOG SITE

ArtWorks from Dessign.net

This is the first of two walkthrough chapters which show you step-by-step how to set up a site using a free theme. I've chosen this particular theme for the portfolio/blog example because of the minimalism of the design and the relative lack of styling, which means it will be suitable for many kinds of creative portfolio site, irrespective of the style of the artworks themselves that are being showcased.

If the vertical image display doesn't suit your work, you will find other themes on the Dessign site, some also free, that showcase your work in a horizontal or square grid format.

The ArtWorks theme is responsive, which means it changes its layout to suit a smartphone or tablet. It allows you to upload a custom background, which adds an individual touch (or you can choose to leave it white, or select a single color). In addition, it has an infinite scroll feature, which means that all items uploaded to the site are displayed on the home page, and appear as the user scrolls down.

You can see the live demo version of the ArtWorks theme here: http://www.dessign.net/artworksresponsivetheme/

How to set up the ArtWorks Theme

1. Install WordPress on your domain.

2. Visit http://www.dessign.net/
art-works-responsive-theme-free-2013
and download the theme.

3. If you're working on a Mac, the
theme may have been unzipped for
you, but you actually need it zipped, so
if this is the case, locate the downloaded
folder (named "ArtWorksResponsive"),
right click on it, and select "Compress
ArtWorksResponsive," which will zip
the folder up again. (If you're working
on a PC, you won't need to do this.)

4. You now need to upload the theme.
Log into your WordPress admin and
navigate to Appearance > Themes.
Click the "Install Themes" tab towards
the top of the screen, and click "Upload."

5. Click "Choose File" and navigate
to the "ArtWorksResponsive.zip" file;
select it and click "Open" or "Choose,"
then "Install Now."
 When it has installed, click "Activate."

Example setup 1: a portfolio/blog site

6. We could click "ArtWorks Settings" and go straight into customizing the theme, but there are a few steps we want to do first in order to get the site ready:

i. Navigate to Settings > General and choose your time zone, so that comments left on your site will show the right time. Click the blue button at the bottom to save when you're done.

ii. While you're building your site, you won't want the search engines to list it, so go to Settings > Reading and select the checkbox next to "Discourage search engines from indexing this site." Save if you make a change.

iii. Go to Settings > Discussion and uncheck the box next to "Allow people to post comments on new articles." This is because you most likely won't want people to be able to leave comments on your site pages, however you may want them to for the blog posts. If so, before starting to post on your blog, you will come back here and switch comments on again. (You can always choose to open or close comments for individual posts or pages. Setting a default here is just a matter of personal convenience.) Click the blue button to save the setting.

iv. Go to Settings > Permalinks, select "Post name," and click "Save Changes." (If you don't do this, WordPress will give you ugly web addresses for your pages and posts (like http://www.yourdomain.com/?p=1) which are meaningless to the search engines.)

v. Go to Users > Your Profile and choose how you would like to be named when you reply to comments on your blog. (You can leave it as "admin," but a real name or a nickname looks much better.)

7. Now prepare your "logo" so that you can upload it to the site. If you're not using a logo as such, you can prepare your name, or the name you want to use as the title of your site, as an image file (.jpg, .png, or .gif) on a white background. (If you don't have a logo as such, and don't really need to create one, see the tip below and on page 105, where alternatives are suggested.) The advised size is about 300 x 100 pixels; it doesn't need to be exactly these dimensions, but much wider would interfere with the menu, and much higher would push the page content down too far.

8. Navigate to Appearance > ArtWorks Settings and click on "Upload your logo."

9. Click "Select Files" and select your logo to upload.

10. When it's uploaded, click "Edit."

GETTING AN UNDERSTATED LOOK WITH ARTWORKS

If you want an understated look, you could match the color and the font of your heading with the menu items. The font used for the ArtWorks menu is Raleway. You can download a free version of the font and then access it through Pixlr (or any graphics program); here I've chosen a mid-gray and sized the font at 24.

Example setup 1: a portfolio/blog site

11. In the window that opens, select the URL (web address) on the right-hand side (make sure you select the entire URL) and copy it. You can safely close the window when you've copied the link.

12. Back in the ArtWorks "Theme Options" area, paste in the link and click "Save Changes."

13. Now prepare your background. If you are going to upload a single large file, you need to check the file size. You don't want a picture larger than 1MB as it will take time to load when people visit your site. This will certainly be the case if you are using a photo or a large scan—in these cases, you'll need to reduce the size as per the example in the box below (you can also do this easily with Photoshop or Photoshop Elements).

If you want a solid color background instead of a background image, create a small file (e.g. 50 x 50 pixels) of that color and save it. Alternatively, if you want to use a pattern or

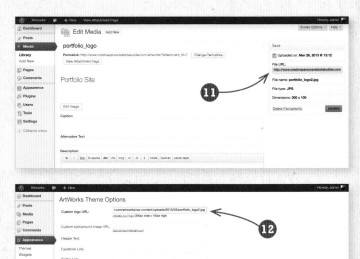

texture, you can obtain a "seamless" one from an online source. If you just want a white background, you don't need to prepare anything.

HOW TO REDUCE THE FILE SIZE OF A LARGE IMAGE WITH PIXLR
Go to Pixlr.com and choose the Pixlr Editor. Choose "Open image from computer" and open your original image; click "Save" from the "File" menu of Pixlr (not the "File" menu of your internet browser). Choose a different name for the new file, and adjust the slider so that the size is no larger than 1000KB. Then click "OK" to save the image to your computer. This will be the file that you upload as your background in step 14.

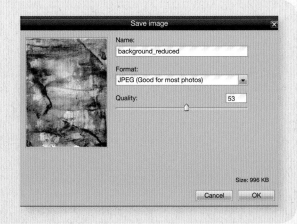

14. Upload your background image, or the small color image file you've just created, to the Media Library. Then in just the same way as you copied the URL of the logo or name file in step 11, copy the URL of the uploaded background image, and paste it into the field entitled "Custom background image URL." (In the case of the solid color file, the system will "tile" it—repeat it—automatically, so the color will fill the entire background space.)

If you want a white background, you can type " " (without the inverted commas) into the field entitled "Custom background image URL" and click the "Save changes" button. This will create a tiny space which will mean the background stays blank—if you leave nothing in the field, the demo background will remain visible. (You won't be able to see the code you've just typed once you've saved the page.)

15. Now, type your home page text into the field entitled "Header Text." Text on your home page is good for Google (see page 140), and a statement or introduction at the top of your website is a big trend at the moment. But if you don't want any text here, simply leave the field blank: if the dummy text from the demo appears on the live site, type " " into the field (without the inverted commas), which will create a tiny invisible space so it appears blank.

16. Now paste your social media links into the allocated spaces. If you need to leave any of them blank, that's fine. (We will look at social media in detail in Chapter 13—you can come back and complete this step later, if you prefer.) Save your changes.

✳ TIP

There's an alternative way you can put your name at the top of the site, which means you can avoid creating a "logo." If you're happy with the look of the font that's used as the heading statement, you can simply write your name or site title into the header text field. You can't leave the logo field blank—if you do, you will see a small graphic appearing on your site indicating that there is an image missing—however there is an easy way around this. Create a very small, white image file in Pixlr, or any graphics program (5 x 5 pixels is fine) and upload it to the Media Library; paste its URL into the "Custom logo URL" field. Your name is now written in text as the heading on the site, and you have nothing visible in the space where the "logo" would be, as shown below.

Text on your home page is good for Google (see page 140), and a statement or introduction at the top of your website is a big trend at the moment.

Example setup 1: a portfolio/blog site

17. The next thing to do is set up the pages on your site. WordPress puts in a sample page for you, which you'll want to delete first. Go to Pages > All Pages and delete it (move your mouse over the page title and click "Trash"), and then create the pages you do want on your site by clicking "Add New." There is no need to create a "Home" page or a "Portfolio" page; we will see about these later. For my setup, I am creating an "About" page, a "Blog" page, and a "Contact" page.

For the Blog page, you need to assign the special Blog layout to it by selecting "Blog" from the drop-down in the "Page Attributes" panel on the right-hand side, from within the page editing area (as shown in the screenshot). Of course, having a blog on your site is optional.

For the Contact page, you'll want to add a contact form; this you can do by activating the Jetpack plugin as per the instructions on page 89.

18. Now go to Posts > Categories. Add a category called "Blog" and the categories you want to group your works into. Here, I am adding categories entitled "Series I" and "Series II," but of course, you will be adding the categories that apply to your own work. When creating your categories, simply type the title into the "Name" field—you don't have to add anything else to any of the other fields on the page. Click the blue "Add New Category" button to save each new category you create.

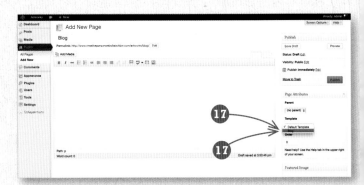

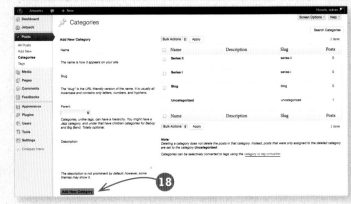

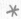

> **✳ TIP**
>
> If you don't want to divide your work up into different portfolios, just create a single category called "Portfolio," or however you'd like to title your work. (You'll also need to create the "Blog" category as well, if you are going to have a blog).

19. Now that you have your categories in place (you can add more as your site develops), you can add them, along with your pages, to a menu. Go to Appearance > Menus and in the field entitled "Menu Name," type "header_menu" (without the inverted commas and with an underscore between the two words). Click the blue "Create Menu" button.

20. You can see the pages you created in step 17 already included in the menu. Now you need to add a "Home" link to the menu, as with this particular theme you don't actually create a home page—the theme automatically pulls together the different elements that make it up. So from within the "Links" pane, type in your domain name next to "URL," and "Home" in the "Label" field. Click "Add to Menu."

21. As you can see from the live demo site, "Portfolio" appears on the menu, but when you click on it, it doesn't actually link to anything—instead, it functions as a title to the Portfolio categories that are beneath it. To do this, create another custom link: type "#" (without the inverted commas) into the "URL" field, and "Portfolio" (or another heading if you prefer, such as "Works") into the "Label" field beneath it. Click "Add to Menu."

22. From within the "Categories" pane, click "View All" and select each of the portfolio categories you created. Click "Add to Menu." You won't add "Blog" as you've already added the blog page to your menu, and you won't add "Uncategorized," since you won't want it showing up as an element in your menu.

23. From within the main area of the page, rearrange the menu items by dragging them into order. Indent the portfolio categories underneath the "Portfolio" item—these will appear as drop-down items. Click "Save Menu."

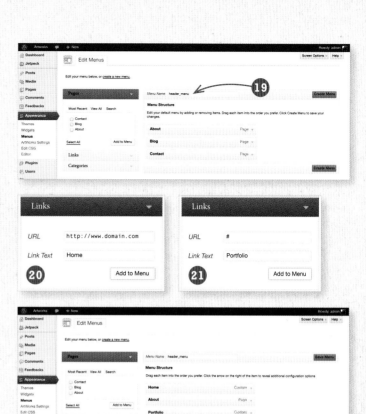

> ✳ **TIP**
>
> If you're not going to use different categories for your portfolio, instead of creating a custom link called "Portfolio" to function as a title for the portfolio categories (as in step 21), simply add your "Portfolio" category directly to the menu (step 22).

SELLING ONLINE FROM YOUR SITE

If you want to sell your products from your site or accept money for any other reason (donations, consultancy, and so forth), you need a way of accepting payments online. Of course, you can always ask your clients or customers to mail you a check, but it almost goes without saying that these days people expect to be able to pay you instantly via an online method.

PayPal

PayPal is the fastest and easiest way of accepting payment online. To accept payments by credit card via PayPal from your site, you need to sign up for (or upgrade to) a Premier or Business account. It will take a few days to verify your bank account and get approval, but it's a simple process, and you'll be able to get up and running as soon as your account is live.

Once you have PayPal in place, you have two choices:

✳ To add PayPal buttons to your site—an easy option if you have just one or two products to sell, or if you want to add a "Donate" button.

✳ To use an e-commerce plugin, which will enable you to use a full-fledged e-commerce theme.

"Donate" buttons let people contribute as much as they want to your project.

Donate

THE PAYPAL SHOPPING CART OR A PLUGIN?

PayPal does have an inbuilt shopping cart option, enabling your customers to group purchases together and pay for them all at once, rather than individually, and this is very easy to set up—just choose a "Shopping Cart" button instead of "Buy Now" or "Donate" when creating buttons, as shown opposite. However if you do have more than just a couple of products to accept payment for, it would be better to use a plugin instead (see page 114), as it will give your customers a much more professional-looking purchasing experience. (You can continue using PayPal even if you're using an e-commerce plugin—there's no need to get a merchant account unless you're ready for that step.)

Adding PayPal buttons or a "Donate" button to your site

Once you're inside PayPal, head to "Merchant Services" and find a link titled "Website Payments Standard"—the PayPal interface changes from time to time, but the place to generate buttons will be inside this area. Click "Create button now."

Choose your button type ("Buy Now" or "Donate"), fill in the item name, price, postage, and other details; you can change the wording of "Buy Now" to "Pay Now," if more appropriate, and you can also set up a drop-down menu if you have variations on offer such as color or size.

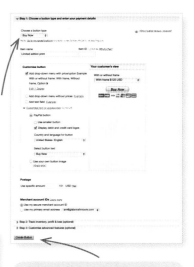

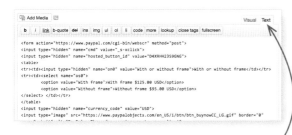

When you're done with the button settings, click "Create Button" and generate your button code.

Select and copy your button code…

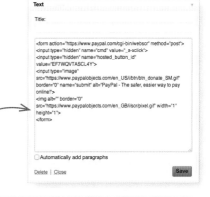

…and paste it into your text area where you want the button to appear, using the "Text" rather than "Visual" view.

If you're adding a "Donate" button, you may want it to appear in the sidebar of your site—in which case, paste it into a text widget in your sidebar, as shown.

Internet merchant accounts and payment gateways

If you plan on selling from your site in any kind of quantity, it will probably make sense to set yourself up with another system for accepting credit card payments, rather than only using PayPal, for two major reasons:

* Withdrawing money from your PayPal account can take several days.
* Although they don't charge a monthly fee to use their services, transaction charges for sales made via PayPal are high.

An internet merchant account eliminates (or reduces the impact of) both these problems.

To use an internet merchant account, you need a payment gateway to act as an intermediary between your website and your merchant account. It is sometimes difficult for small businesses to obtain an internet merchant account directly from their bank; some payment gateways can offer you a merchant account as part of their package, or help you obtain one.

Some well-known payment gateways are Authorize.net, SecurePay.com, PsiGate, BluePay, WorldPay, and SagePay. Where you are located in the world will determine which payment gateways are available to you.

Once you have your merchant account and payment gateway organized, you'll need to choose an e-commerce plugin in order to make it functional—see opposite.

 TIP

It's a good idea to offer your customers different ways of paying. Continue to offer payment via PayPal even once you have your merchant account set up, and if you can cope with the extra work involved, consider allowing people to mail checks to you if they prefer, as well. Depending entirely on what you are selling and how you deliver it, you may also want to allow people to pay you cash on delivery, in person or by bank transfer—if this is the case, allow for these options in your payment setup.

A payment gateway acts as an intermediary between your website and your bank.

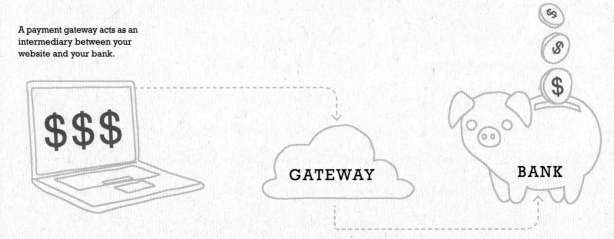

$$\$\$\$$$

GATEWAY

BANK

WordPress e-commerce plugins* *These can be used with PayPal

As we have seen, if you're using PayPal to sell from your site in any kind of quantity, or you're going to use an internet merchant account, you need to use an e-commerce plugin in order to take payments on your site.

There are a number of e-commerce plugins created to work with WordPress. At the moment, the most used are:

* WP e-Commerce (http://getshopped.org)
* JigoShop (http://jigoshop.com)
* WooCommerce (http://www.woothemes.com/woocommerce)

The first two have been around for several years, while WooCommerce is much more recent. However WooCommerce has gained major-player status fast—numerous themes are being specifically designed for it by independent designers, quite apart from a wide selection of themes created for it by its makers WooThemes. In our demo in Chapter 10, we will set up a WooThemes site that runs on WooCommerce.

There are several other e-commerce plugins that you will come across while researching your payment gateway and theme, for example Shopp and Cart66. However in this book we are aiming at obtaining the best results possible with the fewest headaches for non-coders, and with this aim in mind, I'd advise you to go with one of the options above.

You don't need to go anywhere special to find e-commerce themes—just look in the places listed in Chapter 4. It will be indicated if a theme is an e-commerce theme, and the corresponding e-commerce plugin will be specified.

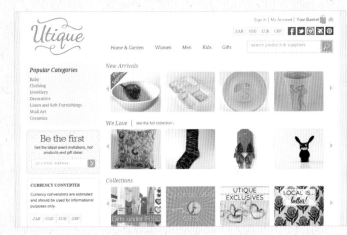

http://www.utique.co.za runs on WooCommerce, using Canvas Commerce by WooThemes.

HOW TO DECIDE ON YOUR PAYMENT GATEWAY, PLUGIN, AND THEME

You'll need to choose your theme in line with your e-commerce plugin and your payment gateway. Different payment gateways are available to you depending on where you are based, and you'll need a plugin that's compatible with your payment gateway. Increasingly, e-commerce themes are being designed with versions that cater to the major e-commerce plugins, but you must check before you purchase.

1. Which payment gateway(s) can you use?
2. Which plugin(s) will work with your payment gateway?
3. Which e-commerce themes work with the plugins you can use?

WordPress e-commerce plugins*

WooCommerce, WP e-Commerce, and JigoShop are three of the best and most-used e-commerce plugins for WordPress. Myriad themes exist for each.

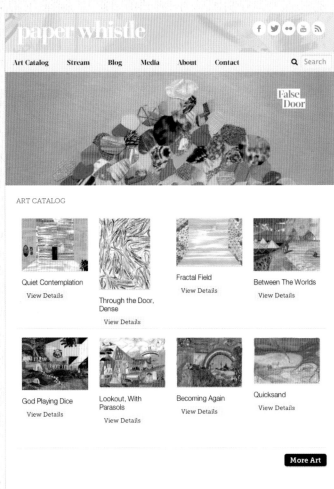

http://paperwhistle.com
runs on WooCommerce.

USING ETSY TO SELL ONLINE

An easy way to sell from your website that will suit some people is to set up an Etsy shop. As we saw on page 99, you can display your items on your website with a plugin. Although it doesn't look quite as professional as running your own e-commerce website, it does give you the added benefit of attracting customers from the Etsy website as well, and it's much quicker and easier than setting up your own system.

SELLING DOWNLOADABLE PRODUCTS

The Easy Digital Downloads and Sell Media plugins make it easy to sell audio, video, and images from your website. See the individual websites for more details (or search the Plugin Directory). Sell Media is developed by the theme creators Graph Paper Press, and specially designed Sell Media themes are in the pipeline. (Both plugins can work with any theme.)

https://easydigitaldownloads.com/demo
http://graphpaperpress.com/plugins/sell-media

EXAMPLE SETUP 2:
AN E-COMMERCE SITE

Mystile from WooThemes (with WooCommerce)
I've chosen this theme for the e-commerce walkthrough because even though it's free, it's highly customizable. "Out of the box" the theme's look is modern and clean, but it can easily be adjusted for a quirkier look suited to a handmade-type site with a quick change of font (achievable easily within the admin area) and a different background. Coupled with the powerful WooCommerce plugin, this will be an excellent choice that will suit many people wanting to sell their wares online.

YOUR PAYMENT SYSTEM
Before you set up your online store, you'll need to have your payment method(s) ready and in place, i.e. PayPal, and/or a third-party payment gateway such as Authorize.net. If you're using a payment gateway you'll also need to purchase the appropriate extension from http://www.woothemes.com; if you're using the standard PayPal service, you don't need to buy anything extra.

You can see the live demo version of the Mystile theme here: http://demo2. woothemes.com/mystile

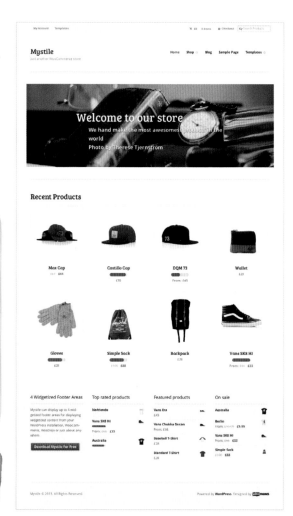

How to set up WooCommerce with the Mystile theme

1. Install WordPress on your site.

2. Go to http://www.woothemes.com/products/mystile and download the theme (you need to register to download it).

3. If you're working on a Mac, the theme will probably have been unzipped for you, but you actually need it zipped to install it, so locate the downloaded folder (which is named "mystile"), right-click on it, and select "Compress mystile." This will zip the folder up again. (If you're on a PC, you can skip this.)

4. You now need to upload the theme. Log into your WordPress admin, navigate to Appearance > Themes, and click the "Install Themes" tab toward the top of the screen. Click "Upload."

5. Click "Choose File" and navigate to the "Mystile.zip" file; select it, and click "Open" or "Choose," then "Install Now."

6. When it has installed, click "Activate."

7. You will see an invitation at the top of the screen asking you to install WooDojo; click on the "Get WooDojo" link. WooDojo is a bundle of tools created by WooThemes that incorporates WooCommerce together with a number of other features, including WooSidebars, a sidebar manager that we will be needing a little later on.

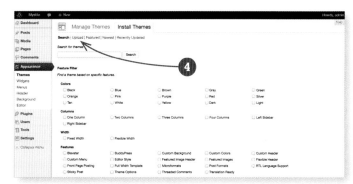

Example setup 2: an e-commerce site

8. A new window will open—click the green button labeled "Download WooDojo for free."

9. Download the plugin. If you're working on a Mac, do exactly as you did with the theme and re-zip it, ready for upload. Navigate to Plugins > Add New > Upload, and install and activate the plugin.

10. You'll see that a new item has appeared in the left-hand navigation of your admin area labeled "WooDojo." Click on it, and scroll down toward the bottom where you see "WooCommerce." Click on the blue "Download & Activate" button.

11. Click on the purple button that says "Install WooCommerce Pages."

12. WooCommerce is now in place, but before we start setting it up, we need to carry out a few steps in order to get the site ready, and we need to customize the theme.

i. Navigate to Settings > General and choose your time zone, so that your blog posts and any comments visitors leave on your site will show the right time. If you need to change your site

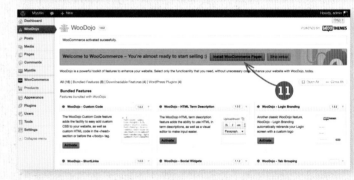

THEME DOCUMENTATION

If you need help or further information while configuring the Mystile theme, you can refer to the documentation by clicking the link shown.

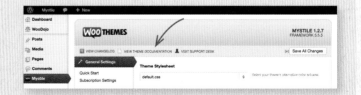

title and tagline, you can do it here as well. Click the blue button at the bottom to save.

ii. While you're building your site, you won't want the search engines to list it, so go to Settings > Reading and check that the checkbox next to "Discourage search engines from indexing this site" is selected. Save if you make a change (the way it is set up now depends on the setting you chose when you installed WordPress). You will, of course, change this later to allow the search engines to index the site.

iii. Go to Settings > Discussion and uncheck the checkbox next to "Allow people to post comments on new articles." This is because you most likely won't want people to be able to leave comments on your site pages, however you will probably want them to for the blog posts. If that's the case, before starting to create your blog posts, you will come back here and switch the comments on again. (You can always choose to open or close comments for individual posts or pages. Setting a default here is just a matter of personal convenience.) Click the blue button to save the setting.

iv. Go to Settings > Permalinks, select "Post name," and click "Save Changes." If you don't make this change, WordPress will give you ugly web addresses for your pages, products, and posts (like http://www.yourdomain.com/?p=1) which are meaningless to the search engines—definitely a consideration when you're selling products that people may be looking for.

v. Go to Users > Your Profile and choose how you would like to be named when you post to your blog and reply to comments. (Of course, you can leave it as "admin," but a real name or a nickname looks much more professional.)

13. With these steps achieved, you can now move on and customize the theme. Click on Mystile > Theme Options. You will see that there are a large number of options available; we will go through the more important ones here.

i. Within the General Settings > Quick Start area of the Mystile Theme Options, you can change the color scheme of the site and upload a logo to replace the default text title and byline that are in position when you first install.

ii. When you click on "Display Options," you can choose to enable "breadcrumbs" on your site. Breadcrumbs are a navigation aid that will help your site visitors find their way around the site—it makes sense to switch them on if you're intending to have quite a few product categories.

iii. Under Styling Options > Background, you can choose a background color or image for the site—one way of making it look truly individual. Go to the "Layout Options" tab and check "Enable Boxed Layout" so your background shows up.

iv. Under Styling Options > Links, you can change your link and button colors.

v. Click on "Typography;" here, you can really have fun with fonts and make your site unique, thanks largely to Google Fonts. You can access the fonts directly through the drop-downs, but it may be easier to look at the fonts available on the Google Fonts website:
http://www.google.com/fonts
There's no way of seeing what they look like on your site without saving them first, so picking a font can otherwise be very time-consuming. Make sure you tick the checkbox at the top of your admin screen, where it says "Enable Custom Typography," otherwise your selection will not show up.

GETTING THE LOOK

Making your site unique

The idea of this book is to show you how to make your website without having any specific technical knowledge relating to website-building. As a creative person, you may find yourself feeling constrained by not having total control over the layout in the way that a web designer would—having to use a design that has already been created and built by someone else.

However, there are many ways in which you can make your website look individual. The easiest trick in the book to add personality is to choose an interesting background and change the font of the headings—or create a header image with an unusual font—giving you an instantly individual-looking site, even if the theme you're using is very simple.

Using Google Fonts
Google Web Fonts offers hundreds of beautiful fonts. The easiest way to implement these is via the WP Google Fonts plugin. The plugin doesn't let you see what the fonts look like, so the best thing to do is choose one you like by browsing the Google Web Fonts Directory (http://www.google.com/fonts), then using the plugin to see what it looks like on your site.

I suggest leaving the font of the regular text on the page the way it is (it's important that the regular text on the site remains clean and readable) and only changing the font of the large headings—choose

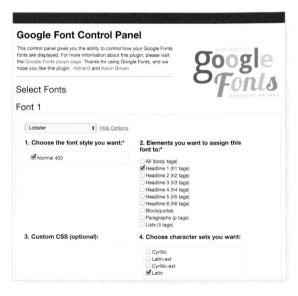

"Headline 1 (h1 tags)" from within the Google Fonts plugin settings.

Creating a header image with an interesting/impactful font
This is another way to make an impact. You can easily download free fonts to your computer (see the Resources section) and use these to create graphics, even if you're using an online service like Pixlr.

Even a simple theme can be made
to look stylish with a bold header.

http://www.poppytalk.com

http://moddea.com

http://www.booooooom.com

http://hermetik.fr

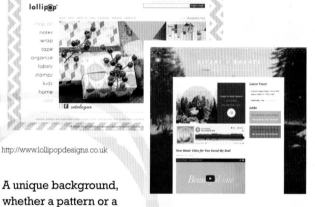

http://www.lollipopdesigns.co.uk

A unique background,
whether a pattern or a
photo, gives a website an
immediate personality.

http://riversandrobots.com

http://www.impressivework.com

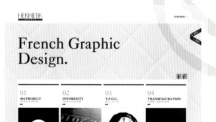

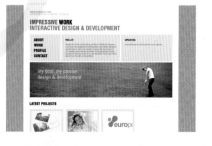

Making your site unique

Get some unique graphics

A beautiful header design or hand-drawn lettering coupled with a very simple theme may be all you need to make your site stand out. If you're a graphic artist then this will be simple; if not, it may be worth considering hiring a graphic artist to make you a header. This is a very effective and easily achievable way to make a site stand out, even if you are using a theme with few bells and whistles. (See the Resources section for some places where you could find a graphic designer to do this for you.)

GET THE LOOK

The examples on the following pages show some design and layout elements that you will certainly have noticed while browsing the web, some of them right up-to-the-minute and others more classic. With each example of a live site are theme suggestions you can use to recreate a similar look.

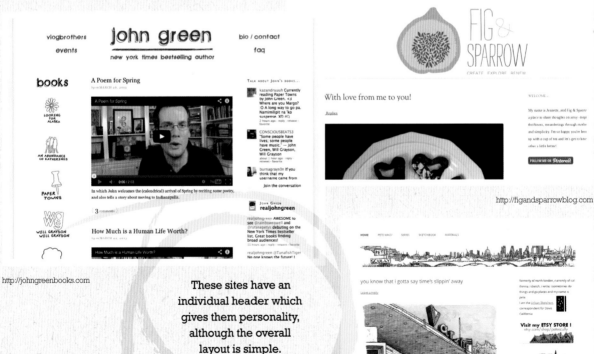

http://johngreenbooks.com

http://figandsparrowblog.com

http://petescully.com

These sites have an individual header which gives them personality, although the overall layout is simple.

One page site with a retro feel

Live site: http://ishothim.com

Retro Portfolio (opendept, ThemeForest)

Different shapes
(other than rectangular or square)
for your portfolio/gallery thumbnails

Live site: http://builtbybuffalo.com

Brankic BigBang (Brankic1979, ThemeForest)

Spun (Caroline Moore, WordPress Free Themes Directory)

Images scrolling from the right

Live site: http://paulgiguere.com

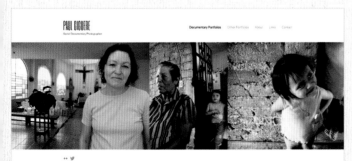

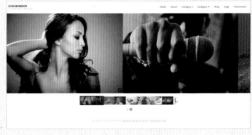

Sidewinder (Graph Paper Press)

Making your site unique

"Masonry style" display

Live site: http://www.coullon.com

Brick + Mason (theMOLITOR, ThemeForest)

Inspire (boostdevelopers, ThemeForest)

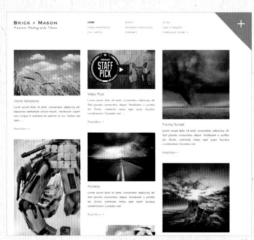

Block display

Live site: http://www.danielvane.com

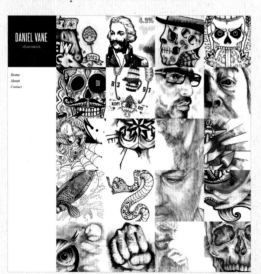

Cubrik (seench, ThemeForest)

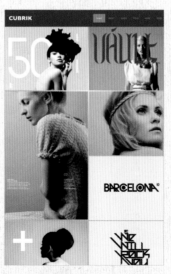

Simon (zlatan_pham, ThemeForest)

Twin (SaurabhSharma, ThemeForest)

Minimalist portfolio layout to display work or products
Live site: http://www.zakandfox.com

Grid Press (Dessign)

Full-screen image viewing
Live site: http://www.sarahcheng-dewinne.com

Photogra (designesia, ThemeForest)

Photolio (kotofey, ThemeForest)
(Both these can showcase full-screen video, as well as photographs.)

Minimalist image display with very little styling
Live site: http://nicolaparente.com

Lightbox (Photocrati)

Showcase

http://www.gwladysdarlot.com (Workaholic, Graph Paper Press)

http://hannaduhita.com (Eureka, ColorLabs)

http://paulhillillustration.co.za (Sidewinder, Graph Paper Press)

http://rurikbjornsson.com (Sidewinder, Graph Paper Press)

http://www.tamareadler.com (Studio, Organic Themes)

http://www.rocioferreras.com (PhotoGrid, Dessign)

http://www.hebervega.com (Emporia, Graph Paper Press)

http://akikohayashi.com (Workaholic, Graph Paper Press)

http://www.vinodkphotos.com (Modularity, Graph Paper Press)

Showcase

http://www.scribblelinens.com (Agency, StudioPress)

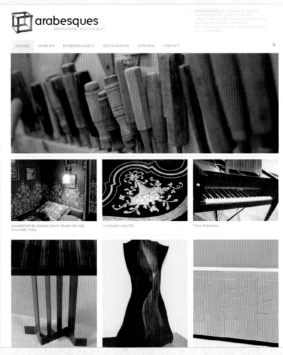

http://www.arabesques-ebenistes.com (Architekt Theme, Dessign)

http://www.arxi.se (Architekt Theme, Dessign)

http://www.sophiedelaveau.com (Albedo, Graph Paper Press)

http://matutomusic.com (IndieFest, Foxhound Band Themes)

http://tigerfriendscollective.com (Minuet, Colorlabs)

http://musictrajectory.com
(Structure Theme, Organic Themes)

http://suzannebag.com (Sentient, WooThemes)

Note: Some of these sites might not have been built with themes as they come "out of the box"—certain aspects may have been customized by a programmer.

12 LETTING THE WORLD KNOW

Once your site is built, you're obviously going to want people to visit it. The kind of promotion you do for your site will depend entirely on who you are and what kind of site you have. For example, an artist won't be using Google AdWords, whereas these may be appropriate if you have a store selling your products. Here are some ideas for promoting your website.

SEO

Search Engine Optimization—or SEO as it is most usually called—is the first thing you need to consider when you're thinking about getting visitors to your site. It's a necessity that will apply to all kinds of website; whatever it is that you do, you will need to make sure that people can find you in the search engines.

If you think that most people are going to be looking for your site by name, then your task will not be hard. But if you imagine your visitors finding you by typing a more generic keyword or phrase, such as "illustrator, London," you will find this process more of a challenge as it will most likely be much more competitive.

The first thing to realize about the search engines is that getting a good listing is not all about trickery. The search engines (Google, of course, being the most important) have a sorting method (which is frequently adjusted) to make sure their search results are the best and the most relevant for their users. Site owners need to work in line with their methods to make their sites as "readable" to the search engines as they can, and show them in the best light possible. How can you do this?

Firstly, the search engines take into account the WORDS on your page in order to classify your site. This means, of course, that you have to actually have some words on your site for Google to be able to read them. Google can't read images, and although the titles and "alternative text" descriptions you assign to them do have importance (see box opposite), if you have a primarily visual site, you will need to make sure that you have some text there as well. (And the text has to include the right words.)

Secondly, there are a number of technical considerations to take into account as well, such as how you title your pages and the "description" you give to each page on your site (more about these over the page). These are read by the search engines, as well as the text on your pages, and used to analyze the subject matter of your website.

Then there are the factors that are external to your site that determine how high up it will appear in the

rankings. Sites that get a lot of traffic are considered important and relevant, so they will be listed more highly than sites that receive minimal traffic. As well as this (and to a certain extent, connected to it, as links can bring traffic) is the fact that sites that have a lot of other sites linking to them will also be regarded as more important than sites that have none. These will be seen as important in their sector as they are being "talked about" by a significant number of others.

So, in summary, to get a good search-engine ranking, what you can do for your site is as follows: firstly, you need to have words on your site, and those need to be the right words; secondly, you need to pay attention to some technical matters such as page titles and descriptions. Thirdly, in order to get traffic to your site, you need to promote it, which you can do both on- and offline, and you also need to ensure that you have other sites in your field of interest that link inwards to your site.

Two other factors worth bearing in mind are that the search engines rate larger sites more highly than smaller ones—that is, as long as the content is all relevant—and that they also favor sites that update their content regularly.

The wording on your site

What do I mean by the "right words?" These are the words you imagine people using to search for you, known as "keywords" or "key phrases." "Children's puppeteer London," "graphic designer Philadelphia," for example. Here's how to incorporate these words:

* Put a brief text explanation about you on the home page of your site. Remember that Google can't read images, so even if your logo includes a tagline in the image file that includes your search terms, you need to include those in actual text as well. The home page is the most important place to put this explanation; even if you have an "About" page that goes into more detail about what you do, you need to put at least a brief description on the home page too.
* The main heading on a page is the most important place to put your keywords. This is known as an "h1" heading (simply because this is how it is labeled in HTML, the basic programing language for websites). This can be the main title of your WordPress page, but you can also put "h1" headings into the text by assigning them the 'Heading 1'' format from inside the text editor.
* If you can repeat your keywords in a page, do. You want your wording to sound natural, but ideally, your keywords should be repeated in the middle and at the end. If you can't do this without it sounding weird, my advice is not to. It can alienate your visitors if your website text looks as if it has been specifically designed for the search engines.
* If your site is a portfolio site, include text descriptions, even if brief, for each piece of work—if there is a description, your site stands a chance of appearing as a search result.

LABELING YOUR IMAGES

The way you name your images can have an impact in the search engines. Make sure you save your images and upload them to your site with meaningful filenames, rather than numerical ones. Also, be sure you give titles and "alt" (alternative text) titles to your images—this can be done within the Media Library. ("Alt" titles are used when a browser cannot receive images—this rarely happens today now that fast connections are commonplace, however these labels are important for their search-engine value.)

SEO

Technical matters

Luckily, there is an easy way to deal with the technical part of SEO and that's to use the All in One SEO Pack plugin (page 92). This enables you to easily insert three elements into each page of your WordPress site:

✶ The page title—this is the title at the top of your browser window and the title that will appear when your site is listed in Google. It shouldn't be longer that 65 characters; make sure your keywords appear in it.

✶ The page description—this is the short description that will appear underneath the title in Google. You need to make it sound interesting, as this is what will encourage people to visit your site, and it needs to include your keywords in a natural way. Don't go over 165 characters.

✶ The keywords—these won't appear anywhere but we need to put them in. Make a list of up to 20 possible keywords or phrases and separate them with commas.

When you have these ready, install the All in One SEO Pack plugin and activate it; click the link to go to the admin page (or navigate to All in One SEO General Settings). Enable the plugin and add the information to the "Home Page Settings" pane. (You can safely leave the other settings the way they are.) Then click the "Update Options" button at the bottom of the page.

Note that now you have the plugin set up, you can change this information for each page or post on your site by scrolling down underneath the text editing box and adding the required content. If

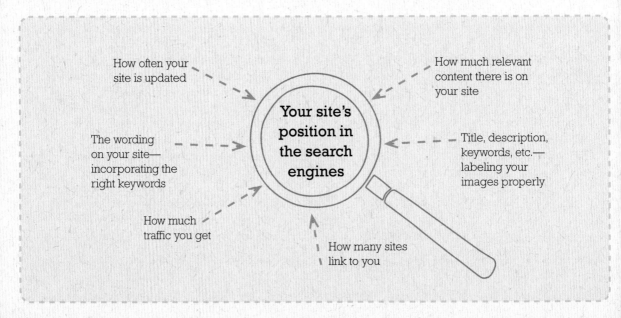

How often your site is updated

How much relevant content there is on your site

The wording on your site—incorporating the right keywords

Your site's position in the search engines

Title, description, keywords, etc.—labeling your images properly

How much traffic you get

How many sites link to you

you don't add anything for an individual page or post, the default that you configured on the main admin page will show up.

Submitting your site to the search engines

Google is by far the most important search engine, but you need to submit to Bing as well, as it has a part of the market share (Yahoo is powered by Bing).

✳ **Submit to Google**
https://www.google.com/webmasters/tools/submit-url
(You will need to have, or set up, a Google Webmaster Tools account.)

✳ **Submit to Bing**
http://www.bing.com/toolbox/submit-site-url

It may take a few weeks for your site to show up in the listings, so don't panic if you don't see it right away.

Requesting a crawl from Google

If you submit a large amount of new content to your site, you may want to ask Google to crawl it again to make sure it is listed as quickly as possible. This is a little bit complicated, so here's how to do it. Log in to your Google Webmaster Tools account and add your site. Install the Google Site Verification plugin to your site, and use it to verify your account. Back inside your Google Webmaster Tools account, click on the name of your website, then "Health" on the left-hand side. Click "Fetch as Google" and type the web address that you want Google to crawl, leaving "Web" selected from the drop-down. Click "Fetch;" when you see "Success" under "Fetch Status," click "Submit to Index." Choose "URL and all linked pages," and click "OK."

Adding a Google sitemap

Install the Google XML Sitemaps plugin, navigate to Settings > XML Sitemap, and click the link where you see "The sitemap wasn't built yet. Click here to build it the first time." This is a good way to ensure that Google never misses new content you add to your site. (The sitemap won't be visible on your site.)

TIP

Before you submit to the search engines, go to Settings > Reading and make sure that the checkbox next to "Discourage search engines from indexing this site" is unchecked!

Other ways of marketing your website

You need to put at least the basics of SEO into place in order for your site to be found by potential visitors, but there are many other things you can do as well to increase the exposure of your site.

Social Media

This can be one of the most successful ways of drawing attention to your site and attracting new visitors, enabling you to interact with people who would otherwise have never heard about you. Social Media is so important that we'll talk about it in a chapter of its own—see Chapter 13; also consider " Facebook Ads" (page 149), a highly successful way of attracting new admirers, fans, and buyers.

Blogging

We mentioned that the search engines like sites that update their content often, and that sites with some substance stand more of a chance of a higher ranking in the search engines. Maintaining a blog on your site ticks both these boxes, as well as helping you market your site.

Entering into the blogging world within your field has the potential of sending dozens of new visitors your way, with guest posting being a very popular method of attracting a new audience with a similar field of interest. Guest posting is when you submit a post for inclusion on another blog in the same, or a complementary, field of interest as yours. Obviously, this idea won't fit all fields, but many blogs welcome the input of others.

You can also make new connections and attract new readers by commenting on other people's blog posts. You should never blatantly advertise your own site, as the point is to interact in a community, but you are always allowed a "signature"—that is, a link to your website at the bottom of your post.

Getting your work or products reviewed

Getting a review of your work or your products online is a wonderful way of getting free advertising and traffic to your own site.

Google AdWords

You have no doubt noticed the adverts at the top and to the right-hand side of the page that appear with your search results when you submit a search on Google. These are called Google AdWords and they are an excellent way of driving potential purchasers to your site.

This kind of advertising is called "Pay Per Click" (PPC) as you pay Google a small amount for each visitor that clicks on your advert and gets taken to your site. The price varies depending on the keyword for which your advert will show up, and to make sure you stay within your advertising budget, you can set a daily limit.

Advertising on other websites

Many websites and blogs carry advertising, either in the sidebar or within the content of the blog posts. Email to enquire about their advertising rates if you can't find any information published on the site.

> Google AdWords Express is a paying service that allows you to set up adverts that appear with a blue marker within the Google Map box.

Google Places for Business

If yours is a bricks-and-mortar creative business, it will be a good idea to get listed with Google Places. This will mean that your site shows up with a geographical search, for example, as in this search for "illustrator London:"

On top of this, when moused over, details of your business, plus samples of your work, appear to the right of the listing—you therefore get a chance to engage the person searching before they've even visited your main website.

Google Places for Business can still work for you if you work from home or if you don't have an "office" as such, as you can instead choose to put your "Service Area" and hide your actual physical address.

To sign up, go to:

http://www.google.com/local/add

and sign in with your Google account details.

Sites listed with Google Places appear here.

Get listed

Getting listed on association websites or portals in your field is an effective way of raising your visibility (as well as your Google ranking).

"Real-world" promotion

* Carry cards and postcards and give them out
* Distribute fliers (where appropriate)
* Press coverage—do you know anyone who can write you up (whether on- or offline)?
* Don't forget to include an email signature at the bottom of all the emails you send.

Joining an association that lists your details on its website is a good way of raising your profile.

PORTFOLIO IN YOUR POCKET

Moo.com allows you to publish as many different images as you like in each pack of business cards.

SOCIAL MEDIA

Using social media is an amazingly effective way of networking and bringing your site—and your works or products—to the attention of a potentially huge array of people who wouldn't otherwise have come across you.

Facebook and Twitter are now household names, but let's clarify what we mean by "social media:" it is a collection of different, independent services that let users share opinions, recommendations, and images through a network of other users that can spread from your own connections through a much broader web, and thereby get the attention of hundreds of new and potentially interested people.

Here's an introduction to some of the social media services that may be useful for those in the creative world, and how to integrate them into your website. Which social media you use depends on what other people in your field of interest are using—you won't usually use them all.

There are dozens of different plugins to help you display your social media links on your website. I've described here what I think are the best and easiest ways of incorporating them, but if you are looking for different display options, have a browse around the Plugins Directory.

THE JETPACK PUBLICIZE AND SHARING TOOLS

The Jetpack Publicize tool lets you link your site so your blog posts get posted on your social media networks automatically.

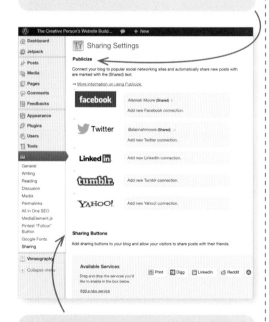

The Sharing tool puts social media buttons on your pages and posts so visitors can share them with their own networks.

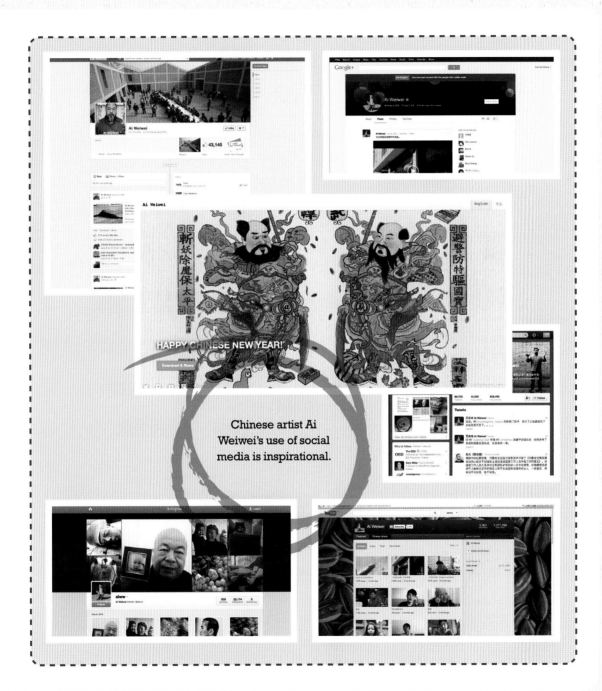

Chinese artist Ai Weiwei's use of social media is inspirational.

147

Facebook

Facebook is probably the best known of the social networks, mainly because people have used it for some years now in their personal lives to share photos and news with their friends and family. To use Facebook as a communication tool to promote your work and your website, you need to sign up for a "business page," rather than a personal account, as this will enable you to use the "Like" facility.

"Liking" a Facebook page simply means clicking the thumbs-up icon towards the top right of the page. Once someone has "Liked" your page, your announcements will appear in the activity stream of their own page, and unless they've switched their settings so that people can't see their activity stream, other people who visit their page will also see your post.

You can sign up for a business page without first having a personal Facebook account.

A Facebook business page is great for quick news updates like sharing pictures of new products and making announcements, as we can see here with the Design*Sponge Facebook page; people can also comment on your posts.

Sign up for a Facebook business page at http://www.facebook.com

Integrating Facebook with your site

People may stumble upon your Facebook page through other people's activity streams and Like you that way, but you'll also want people who visit your website to be able to Like you. The best way of doing this is setting it up so they can do it spontaneously without leaving your site.

An easy way to embed a Like button into your site is via the Jetpack Facebook Like Box widget; this allows you to choose whether to have a grid of little square faces—which you've probably seen on other websites—and/or a stream of activity appear beneath the Like icon. You may feel that including faces adds life to your website, however, for some sites with a more minimalist look, this will be totally inappropriate. It's your choice.

As well as allowing people to Like you on Facebook, you also want to allow them to "Share" on Facebook. This means that they can post the link, plus any comment, onto their own Facebook page, so that their own connections will be able to read about it. A great viral marketing tool! The easiest way to put a Share button into your pages and posts is to configure the Jetpack Sharing feature—see page 146.

Facebook Ads

If you have an event to promote, or simply want to raise your profile by increasing the number of people who Like you, running ads on Facebook is an effective and low-cost way of advertising. Like Google AdWords, you can set a budget and target your prospects by location—age and gender is an additional option. See here: http://www.facebook.com/advertising.

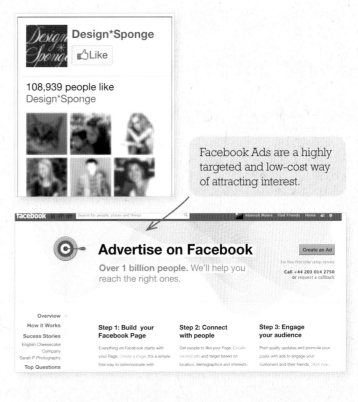

Facebook Ads are a highly targeted and low-cost way of attracting interest.

> **＊SHARE THIS**
>
> You may also find the popular ShareThis plugin useful—a valuable tool that lets you hide multiple "sharing" buttons behind a single, recognizable icon.

＊SOCIAL MEDIA BUTTONS

You will have noticed that many themes come with built-in social media buttons—these look great, however they only link to your home page of each of the social media networks you use. They don't allow visitors to Like or Share, so you'll want to set the latter up as well to use in addition to the built-in buttons.

If your theme doesn't come with built-in buttons, you will want to add them as a reference point for your visitors. An easy and nice-looking way to do this is to use the Simple Social Icons plugin from StudioPress (Nathan Rice). Although there are countless other plugins you can use; just search the WordPress Plugins Directory.

Twitter

Twitter is a "micro-blogging" tool—you can use it to send short messages of up to 140 characters to people all across the world who have signed up to "Follow" you. These messages ("Tweets") are short bulletins of information, shared links, or questions posed to your followers for an immediate response. It's an excellent way of instant messaging with hundreds of people instead of just one.

As with Facebook, you'll need:

✳ A button that takes the visitor to your Twitter home page so that they can see your past Tweets.

✳ A button that allows them to Follow you without leaving your website.

✳ A button that allows them to Tweet your material to their own followers (i.e. send the web address of the page or post they want to pass on to their followers, with their own short comment).

Just as before, the first will often be catered for by your theme. If not, you can use a plugin such as the Simple Social Icons plugin.

To get a Follow button, log in to Twitter, go to https://twitter.com/about/resources/buttons#follow, and select the code in the box. Now go to the admin area of your site, drag a text widget into your sidebar, and paste the code into it (as shown).

The easiest way to add a Tweet button is via the Jetpack Sharing feature.

You may also want to show your Tweets on your site. Some themes have a built-in widget option for this which is styled to match your theme; if not, you can use the Jetpack Twitter widget. (This can also be set to show a Follow button underneath it, but this doesn't show how many followers you have.)

If you want to show the number of followers you have, change "false" to "true" within the code. If this makes it too long to fit in the sidebar, you can choose the option that doesn't show your Twitter name.

> ✳ **TIP**
> When you choose your username, avoid a long name as when people reply to you, it'll eat up part of the 140-character allowance.

Sign up at https://twitter.com

Pinterest

Pinterest is a fun pinboard-style social media whereby users can collect, organize, and share images according to their hobbies and likes. At the outset Pinterest was a focus for crafters, hobbyists, and cooks who posted their creations and their inspirations on their pinboards, but Pinterest now allows users to set up business accounts, reflecting a growing demand for creative professionals to use the tool to get their works and their story out there.

If you're using Pinterest, on your site you need:
* A button to take visitors to your Pinterest home page.
* A button allowing people to "Follow" you on Pinterest.
* A button allowing people to "Pin" your images.

If you don't have built-in social media buttons on your site, you can easily add a Pinterest button with Simple Social Icons or a similar plugin; the Pinterest Follow Button plugin will let you put a Follow button on your site. A "Pin It" button can be incorporated with the Jetpack Sharing feature.

A number of plugins exist to display your latest Pins on your site, the Pinterest Pinboard Widget is one, and the Brankic Photostream Widget plugin (on page 153) is another.

Sign up at https://pinterest.com or http://business. pinterest.com

RECENT PINS

More Pins

Group your works and visual inspirations into different pinboards and let them be "re-pinned" around the web.

PINTEREST FOR CREATIVES:
* Use it as an online portfolio.
* Show your inspirations.
* Show your creative process.
* Show sketches and storyboards.
* Don't forget to add a link in your profile to your main website.
* You can add prices, letting people know your work is for sale.
* You can use it as a collaboration tool, with multiple contributors adding their ideas.

PINTEREST WITH NEXTGEN
If you're using a NextGEN gallery on your site (see page 94), you can use the Pinterest Lightbox plugin to allow people to Pin the images in your gallery.

Google Plus

Google Plus is another way to interact and meet with like-minded others—a great place for creative people to connect and show their work.

Google Plus works rather like Facebook, but its look is more clean-cut, and it's become popular with artists as an additional place to showcase their work online. It's also more interactive than Facebook or Twitter, so it's a good place to get feedback and start online discussions.

If you're going to use Google Plus on your website, you need:

* A Google Plus icon linking to your page.
* "+1" buttons allowing people to endorse your content.
* You may also want to allow people to add you to their circles straight from your web page.

The first two are taken care of by your theme or by an icon widget, and by the Jetpack Sharing tool. The third, you can implement by adding the Google Plus Widget plugin.

Artist/illustrator Daniel Ibanez uses Google+ Hangouts to teach digital drawing and painting and has acquired 1.6 million followers.

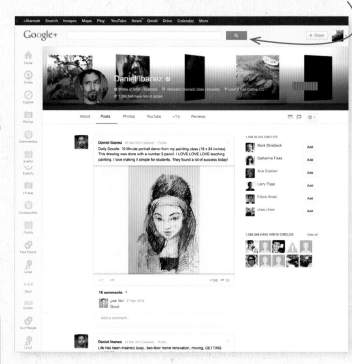

***GOOGLE PLUS FOR CREATIVES:**
* Use it as a portfolio.
* Set up a critique group who can give you feedback, or a working team for collaborative projects—other "circles" will not see the material you post.
* Use the Hangouts feature for collaborative work.
* Don't forget to include all your gallery links or links to other places your work appears.

Sign up at https://plus.google.com (you need a Google account).

Dribbble

Dribbble describes itself as "Show and tell for designers"—it's also often referred to as the Twitter equivalent for those in the design world. You can post small images of work and work in progress and receive comments, and it's a place where new talent is discovered.

As for incorporating it into your site, you may find your theme includes it in the list of simple badges you can display, and if it's a theme created with designers in mind, it may also have a special widget you can use to display your latest "shots."

Failing that, a wonderfully useful plugin exists that can show your Dribbble, Flickr, Instagram, and Pinterest feeds on your site in a uniform way: the Brankic Photostream Widget plugin. (See the next pages for an introduction to Flickr and Instagram.)

Sign up at https://dribbble.com/signup, as a "prospect" or a "scout."

Designers can post small images—"shots"—to show what they're working on.

The Brankic Photostream Widget lets you display your image streams in a clean way on your site.

Flickr

Flickr is a wonderful source of inspiration for creative people, as well as a great way of getting your work, products, or creations seen.

* Be sure to title and tag your images in a useful and accurate way so that people searching the site can find your images.
* You can group your images by "set" which might be various versions available of a certain product, or a series of work. This is a useful way of getting your work seen by more people.
* Add your images to "groups"—again to bring more views.

If Flickr isn't in the icon suite offered by your theme, you can easily incorporate it using another icon suite such as the Social Media Widget (see

> **Sign up at http://www.flickr.com (you need a Yahoo ID).**

page 156), but you'll find it is very often incorporated in themes designed especially for creatives; similarly, a Flickr photostream widget is often included that fits with the layout of your theme. Failing that, there are dozens of options in the WordPress Plugins Directory; or you could opt for the Brankic Photostream Widget, as mentioned on the previous page, which is particularly useful if you also use Pinterest and Instagram.

Flickr is a place to see, and be seen.

Tumblr

Tumblr is another micro-blogging platform, with a visual emphasis and an artistic/creative leaning, so it's perfect for people in the design/ illustration/photography/fashion world. As well as images and videos, people post quotations, audio, and weblinks, and it's so quick and easy to do that it's easier to maintain than a full-fledged blog. It's mostly younger people who use Tumblr—under 30s—so if this is your audience, Tumblr is a place you could be.

Tumblr is great for repurposing, or curating, content from your main site or blog, or from other social media. You could post key excerpts from one of your blog posts, an Instagram image, or a comment from your Facebook, Twitter, or Google Plus page.

A Tumblr icon may not come with your theme, so you'll need to add it with another suite of icons. If you post frequently to Tumblr, you may want to use the Alpine PhotoTile for Tumblr plugin to display your Tumblr posts on your main website, either incorporating them into a page or a sidebar.

Sign up at https://www.tumblr.com/register

Tumblr is the ideal place to hang out for creatives with a younger audience.

Instagram

Instagram is unlike the other social media we've looked at as it's designed to work with your smartphone (Apple or Android) and interacts with Facebook, Twitter, and Flickr so you can post your photos on those platforms. The idea is that you snap a photo with your smartphone and by applying a filter, transform the everyday-looking photo into something far more memorable that resembles an old-fashioned Polaroid—you could see it as a kind of photographic telegram.

This is a fun and addictive tool for creatives—it's taken off vastly since it was launched in 2010, and even more so since it was made available for Android as well as Apple—so it's not surprising there are numerous ways you can choose to show your pictures on your site.

Most simply, you can embed your images using the built-in embed feature of WordPress, whereby you simply paste the URL of the Instagram photo and it will appear on your site. Alternatively you can integrate Instagram with WordPress with the Instagrate to WordPress plugin that will automatically post your Instagram photos. The Simply Instagram plugin is one of the most popular plugins, allowing you to incorporate your photos into your pages or posts or into your sidebar with a widget, or you can use the Brankic Photostream Widget.

*SOCIAL MEDIA BUTTONS FOR ADDITIONAL THIRD PARTIES

The hugely popular Social Media Widget (by Blink Web Effects) lets you put icons in your sidebar linking to 40 different social media/third-party services, including deviantArt, SoundCloud, Bandcamp, Etsy, Goodreads, and Instagram. This is really useful if you don't find all the buttons you want to display included with your theme.

Instagram is great for visual creatives, but also for others who want to build an image of their "personal brand" without necessarily having to draw or design themselves.

Sign up via the App Store or Google Play.

YouTube and Vimeo

If we are focusing on publicizing your work, out of the two leading video-sharing services, YouTube, having the greater audience, will be more effective in attracting new people interested in your creations. However, as we saw in Chapter 6, Vimeo does have the smoother, less commercial-looking interface, and this may suit you better.

A YouTube button to link to your "channel" is included in all icon set plugins, and we've seen how easy it is to embed individual videos straight into your pages and posts (Chapter 6). If showcasing videos is a major part of your website, you'll want to add the YouTube plugin (by EmbedPlus) so that you can track your video viewing stats.

Vimeo icons are not necessarily included in a set of icons provided with your theme, but you'll be able to add them if you use the Social Media Widget (opposite).

*IDEAS FOR VIDEOS

* The creative process—a film of you at work.
* A short film in the form of an interview explaining your influences and the ideas behind your works.
* A short film of you walking around your exhibition and talking about it.
* A how-to demonstration.
* Don't forget to tag the video with your name and website address.

*AVATARS

For "branding" purposes, consider carefully the image you use as your avatar across the social media you use; be consistent as much as possible to convey a coherent image. You may want to choose the same image as for your "gravatar" (see page 165)—that is, the image that goes next to your name when you reply to your blog comments, or when you post in other places across the web.

IN SUMMARY . . .

The sheer number of different social media networks in which you could be participating may seem daunting. If you haven't got the time to be everywhere, choose the ones you will devote your attention to, and post on them consistently. No matter which social media you choose to engage in, you will reap rewards.

KEEPING IN TOUCH

Engaging with your visitors through social media is one way of making sure your visitors don't forget about you. Another way is to get their email address and permission to contact them when they visit your site.

The very simplest way of keeping in touch
The easiest way is simply to use the Blog Subscriptions widget, which is part of the Jetpack bundle. That way, people who've subscribed will receive your latest blog posts as emails. You can see their email addresses (Jetpack > Site Stats > Blog in the "Subscriptions" pane, down at the bottom), but these are not formatted in any way that allows you to email them (and besides, they haven't given you their permission to contact them outside your blog posts), so you'll have to post any news items as blog posts in order for your subscribers to receive them.

An alternative is the Subscribe2 widget (you can find it in the Plugins Directory), which does allow you to email your blog subscribers, but remember that they haven't technically signed up to be contacted outside of the blog, so you have to be very careful not to abuse the fact that you can.

✳AN EMAIL NEWSLETTER?
There are many ways of handling your email mailing list. These will depend on your personal style, what your intentions are, and the field you are in.

✳ One way is to format an actual email newsletter, sending it out regularly, full of interesting information to entertain and engage your readers. This can be a lot of work, but it might suit your domain perfectly, and be just what you want to do.

✳ Another way is simply to send out updates whenever you have a gig, for example, or an exhibition coming up.

✳ A third way is a kind of hybrid between the two. You can send out a message regularly, with perhaps a couple of items of interest to relate to your readers, with links to your latest blog posts explaining what they were about, in case they missed them.

A third-party email list manager

The best solution is to set up an account with a third-party email list manager. This is a far neater way than managing your contacts' email addresses manually via a simple list of email addresses in your email software, which many people do at the outset. With your list managed by an outside service, unsubscribe requests are dealt with automatically, you can greet your subscribers with a welcome message, and you can format your emails in a way that looks attractive and reflects your brand—if you have one, as such—without any hassle.

AWeber and MailChimp are the most popular email list managers. MailChimp's email templates are beautifully designed, but if you're really into stats, Aweber has the more sophisticated tracking tools.

MailChimp allows you a free service up to 2,000 subscribers, so is the choice of many small enterprises—thereafter, the cost difference between the two is negligible.

Both MailChimp and AWeber have plugins that allow you to add a subscribe form to your WordPress sidebar. They also both allow you to integrate your blog posts with your mailing list, so that your subscribers receive your blog posts as well as your mailings.

LEGALITIES

Whether or not you're actually selling from your website, there are certain rules that all website owners have to obey; you may be surprised at the number of regulations that concern you, but it's essential that you toe the line.

Rules vary from country to country and also from state to state. Here, we flag up what you need to be aware of, however you do need to research the laws that apply to you concerning these matters, and any others that may be applicable, depending on your geographical location.

Privacy
Whether or not you sell from your website, you need to publish a privacy statement on your site declaring what you are going to do with any data that is submitted to you (even the names of individuals who contact you via the contact link or form on your website). Details will vary from country to country, but penalties can be serious if you don't comply, so it's important that you check what applies to you.

Cookies
There's been a lot of talk recently about cookies, following the implementation of the EU Cookie Law in 2011. Cookies are tiny files stored on your computer that web pages can access to determine what is shown on the page you are viewing. Often perceived as a spooky spying mechanism, most often they're there simply to improve your browsing experience—for example, showing you certain information the first

time you visit a website, but not on subsequent visits. Whatever their purpose, you, as the owner of a WordPress website, are implicated: now, if you interact with anyone in any of the countries affected by the cookie law, you have to implement a mechanism on your website that allows users to opt in (continue browsing) or opt out.

Luckily, although it sounds complicated to implement, the easy solution is to use a plugin. I use one called Cookie Law Info, but as usual there are numerous options available; browsing the Plugin Directory will allow you to choose one that fits with the look of your site—doing the job as it's meant to, without being too intrusive.

Copyright & trademarks
As soon as you create a work of art, the only person who is legally allowed to copy that piece of work is you. You do not need to put the copyright symbol (©) next to works that you publish online, however it will remind people not to copy it, and should you ever need to go to court over the illegal copying of your work, you will have a very strong case if you did show the copyright symbol next to it.

It's optional to actually register your works, but if you want to, apply to the copyright office of the country where you are based. You may be happy to allow others to reproduce your work but want to restrict what they can do with it; if so, you can go to http://creativecommons.org and generate a license. You will need to register a trademark if you want to

create a unique brand for your products or services—this will prevent it being stolen further down the line and, equally, you'll want to make sure you're not treading on someone else's territory.

Email

You may already be aware of laws regarding commercial email. Stiff penalties can be exerted from those who do not comply, but it isn't hard to follow the rules, which are basically as follows:

* Don't add people to a mailing list unless you have their permission. This means you can't add people you already know or people you meet (although there's nothing stopping you emailing your contacts and asking their permission). You are allowed to add past customers directly into your list.
* Your message needs to show your correct email address.
* Never use a misleading subject line.
* If the message is an advert, rather than an update, you need to make this clear.
* You need to include your physical address (if you use a mailing list manager, your emails will automatically include this information).
* Tell people how they can unsubscribe, and honor the requests immediately (as above, this will be taken care of by your mailing list manager).

For more precise details, see the CAN-SPAM link in the box on the right.

Business permits and other legal requirements

Depending on where you are, you may need a permit to do business from your home or studio; if you're doing business overseas, you'll need to check you comply with international trade laws.

USEFUL LINKS

The following links may help you get started, but do research what applies to your own location.

http://www.sba.gov/community/blogs/community-blogs/business-law-advisor/creating-privacy-policy-your-online-business (US privacy policy guidelines)

http://www.ico.gov.uk/for_organisations/privacy_and_electronic_communications/the_guide/cookies.aspx (EU Cookie Law)

http://www.business.ftc.gov/documents/bus61-can-spam-act-compliance-guide-business (CAN-SPAM Act)

http://www.hg.org/trade.html (International Trade Law)

http://www.copyright.gov (United States Copyright Office)

http://www.copyright.gov/circs/circ40.pdf (Copyright Registration for Works of the Visual Arts)

http://www.internetlegal.com/trademark-law-and-the-internetcopyright-law-and-the-internet (Trademark and copyright law and the internet)

http://www.uspto.gov/trademarks/index.jsp (US Patent and Trademark Office)

16 RESOURCES, TIPS, AND TOOLS

Maintaining WordPress

Backup

It's essential that you back up your website on a regular basis. Both the database and the content of your site need to be backed up—this can be done automatically and scheduled regularly so you don't have to remember.

Two good plugins for this are:

✳ BackUpWordPress
You can set a backup to run at regular intervals and save to your host automatically. You'll also be sent a download link by email, which you need to click on to download a copy of the backup to your computer, just in case anything ever goes wrong with your host.

✳ WordPress Backup to Dropbox
Schedule automatic backups to be stored on Dropbox. (Dropbox is a very useful online storage utility that allows you to store and share documents and images.)

Updating

The WordPress system is upgraded frequently and you should keep up to date, both to benefit from the improvements to the system, and ensure your site remains secure.

It's easy to update the system—WordPress notifies you within your admin area and you simply click the link that says "Please update now." You will also be notified when your plugins need updating and this you should do as well.

Be sure to do a backup before you upgrade, just in case anything goes wrong, and take the time to check everything works properly afterwards as well.

Making your site run faster

A site that loads slowly is frustrating for your visitors and it's not good for the search engines either. Look at ways you can improve your site's loading speed, especially if your website has lots of graphics.

✳ Optimize your database—it tends to get cluttered up. You can do this with a plugin: WP-Optimize.

✳ Optimize your images. Images can contain a lot of information that you don't need. Using the WP Smush.it plugin will compress your images and remove unnecessary information without compromising their quality.

✳ Use the W3 Total Cache plugin. This will prevent your site loading pages from scratch each time people visit.

✳ Keep your admin tidy. Use only essential plugins— delete ones you've installed that you "might" use some day—delete unpublished comments, empty your trash, and update your plugins when needed.

Quick ways to update your site

Press This
Press This is a little bookmarklet that lets you clip text and add weblinks direct to your blog, without leaving the website you're on.

Managing your site from your smartphone or tablet

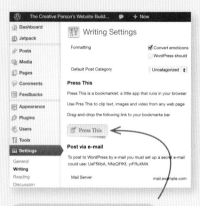

You can post to your blog and update your site while on the move with the WordPress app (for iOS, Android, BlackBerry, Windows Phone, Nokia, and WebOS).

Drag the "Press This" button onto your browser links bar…

…and publish directly to your site.

Posting by email
Jetpack makes it wonderfully easy to post to your blog directly by email. Configure the "Post by Email" feature of the plugin, save the special email address to your contacts, and post from your smartphone or tablet by sending emails (including images) to the new address.

Working as a team

If you have other people contributing to your site, it may be convenient for them to have separate logins so they can post on the blog and administrate the site under a different name. You will probably also want to allow different users to take charge of different tasks on the website.

The different roles are:

✳ **Administrator**
Someone who has access to all the admin features (just as you do).

✳ **Editor**
A user who can publish and manage posts and pages, even those created by others. But an editor can't change the theme, for example.

✳ **Author**
A user who can publish and manage their own posts.

✳ **Contributor**
A user who can write and manage their own posts, but not actually publish them (someone else with a higher level has to OK them before they appear on the site).

✳ **Subscriber**
A user who can only manage their profile (this would only really be used for a private blog, as otherwise this is just the same as an unregistered site visitor).

👥 **Add New User**

Create a brand new user and add it to this site.

Username *(required)*

E-mail *(required)*

First Name

Last Name

Website

Password *(twice, required)*

Strength indicator *Hint: The password should % ^ &)*

Send Password? ☐ Send this password to the ew user by email.

Role Subscriber ⬍

Add New User

Add users within the Users > Add New area, and select the role you want to assign to them.

HOW TO GET A GRAVATAR

If you want to show a customized picture, rather than the generic one, when you, or someone else in your team, replies to posts left on your blog, then you need to sign up for a gravatar (and get the other members of the team to do so, as well).

A gravatar simply means a "globally recognized avatar." The system was set up by the same people who developed WordPress, but the avatars will show up in other places on the web where you sign in with the same email address.

To get a gravatar, go here: http://gravatar.com

Once you've signed up and uploaded an image, go back to your WordPress admin and from the Settings > Discussion area, check "Show Avatars."

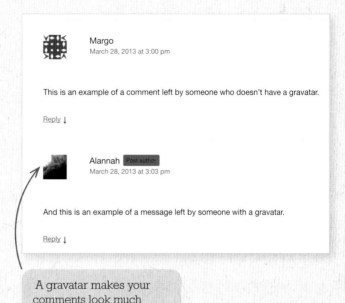

A gravatar makes your comments look much more personal.

This is what happens when someone mouses over your gravatar.

...th a gravatar.

See also the note on using avatars for social media on page 157.

WordPress in your language

At the time of writing, WordPress exists in 74 different languages and this development is continuing, so although its basis is in English, it's designed as a global project.

From the main WordPress website you'll be able to download the version in your language and install it according to the instructions: http://codex.wordpress.org/WordPress_in_Your_Language.

If you've chosen a hosting company that's based in your country, it's possible that their install system will install WordPress in the right language for you, which will save you doing a manual install—ask to check. Otherwise, you will need to perform a manual installation.

Things are more complicated when it comes to complex themes, which come with their own set of wording that's additional to the basic WordPress system. You will only be able to use these themes if they conform to a standard way of preparing their wording. If a theme conforms to these standards, it is called "translation-ready."

✳ Ask the theme creator if the theme is "translation ready."
✳ Ask if they have any language files ready in your language. If they do, you will need to add them to the "languages" directory within your theme folder.

If they don't have the language files ready, you'll need to do the translation yourself, and generate the files. This you can do by using a plugin called Codestyling Localization. You translate the words and phrases that will appear on the live part of the site, and the plugin generates the necessary language files the system needs to display them.

✳ **YOUR WEBSITE IN MULTIPLE LANGUAGES**
If you need your site in several languages, you can use a plugin such as QTranslate, which allows you to create different language versions of every page and post, or the popular premium plugin WMPL, which you'll need if you're using a more complex, premium theme (http://wpml.org—you'll need the "Multilingual CMS" version).

Getting help with WordPress

Built-in help
On each page of the admin area is a "Help" tab offering information about the particular area you are in.

This is the first place to look if you need help.

You'll probably find an answer to your question already posted on the forum.

The WordPress website
The WordPress website has a helpful support section at http://codex.wordpress.org and a forum at http://wordpress.org/support/forum/.

There's a lot of information on the WordPress website including WordPress Lessons and an FAQ section.

Resources

Where to find a designer or developer

Tweaky https://www.tweaky.com

Code Poet Directory http://directory.codepoet.com

Elance https://www.elance.com

Freelancer.com http://www.freelancer.com

ODesk http://www.odesk.com

Smashing Jobs http://jobs.smashingmagazine.com

WP Hired http://www.wphired.com

WPMU Jobs http://premium.wpmudev.org/wpmu-jobs

Creattica http://creattica.com

Dribbble http://dribbble.com

Etsy http://www.etsy.com
(search "WordPress theme" and then contact the developers directly)

Themeforest http://themeforest.net
(you can contact the developers directly)

Creative Market https://creativemarket.com
(as above)

Where to find graphics and backgrounds

(In all cases, be sure to check the license/ask permission/give credit as required.)

Colour Lovers http://www.colourlovers.com/patterns

Subtle Patterns http://subtlepatterns.com

DinPattern http://www.dinpattern.com

DesignMoo http://designmoo.com/category/patterns

Striped Backgrounds http://stripedbgs.com
(generator)

Tartan Maker http://www.tartanmaker.com
(generator)

Creative Market https://creativemarket.com/graphics

Free Fonts

http://www.google.com/fonts

http://www.1001freefonts.com

http://www.dafont.com

http://www.fontsquirrel.com

Experiment with color

Adobe Kuler https://kuler.adobe.com
(a great place to play with color combinations)

Colour Lovers http://www.colourlovers.com

Image editors

Gimp http://www.gimp.org

Pixlr http://pixlr.com

Paint.net http://www.getpaint.net

http://www.picmonkey.com
(create collages and apply text to images)

Logo design

Design Crowd http://www.designcrowd.com

99 Designs http://99designs.com

BuildaBrand http://buildabrand.com

WordPress links

http://wordpress.com
(the home of the hosted version of WordPress)

http://wordpress.org
(the home of self-hosted WordPress)

http://codex.wordpress.org/FAQ
(Frequently Asked Questions)

http://wordpress.org/support (support forums)

http://wordpress.org/extend/themes
(free themes directory)

http://wordpress.org/extend/themes/commercial
(commercial themes directory)

http://wordpress.org/extend/plugins
(plugin directory)

Creattica http://creattica.com

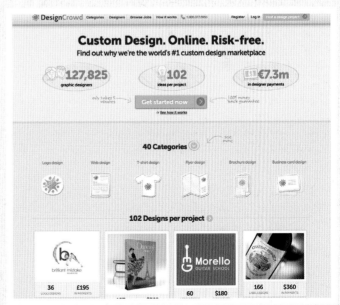

Colour Lovers http://www.colourlovers.com

Design Crowd http://www.designcrowd.com

Website builder roadmap

You've covered a lot of information in this book. To keep you on the right track whilst building your site, here's a roadmap you can use to guide you.

1. Purchase your domain name and set up your hosting.

2. If necessary, change your nameservers so that your domain name connects to your hosting—this won't be necessary if you've set them up through the same company (page 19).

3. Install WordPress (page 22).

4. Choose your theme and purchase it if necessary.

5. Install your theme (page 82).

6. Log into your admin area and navigate to Settings > General. Check your title and tagline are as you want them; change the time to your time zone.

7. Go to Settings > Reading and choose to discourage search engines from indexing your site (this is just while you're building the site).

8. Go to Settings > Discussion and choose whether you are going to allow people to post comments on your pages and blog posts by default (you can override this on individual pages or posts).

9. If you are going to have a blog on your site, you may want to change the way your user name is displayed. Go to Users > Your Profile to give yourself a nickname or put in your real name (if you don't make a change here, your posts will be posted by "admin").

10. Change your permalinks (page 66).

11. Customize your theme—upload your logo, change the background, and carry out any other customization your theme allows you to do, such as perhaps changing colors or fonts. If your theme is a premium theme, refer to the documentation that comes with the theme, and pages 84–85 may also help you.

12. If your site is an e-commerce site, you'll need to install the e-commerce plugin you're using before you go any further.

13. Does your theme create a home page for you? If not, you may want to create a home page and set it so that your blog posts don't appear there (page 64).

14. If you are going to have a blog section on your site, create a blog page and set it so your blog posts do appear on it (page 64). Depending on your theme, you may not need to do this; you may simply need to assign a blog layout by using the Template drop-down in the Page Attributes pane (page 85).

15. Create the other static pages on your site, and any portfolios or galleries. You will probably

need to assign page layouts, as above. When deciding on the wording for your pages, make sure you consider the search engines, according to the information in Chapter 12. Also, make sure you check your contact form, if you put one on your contact page, to be sure it works correctly.

16. Hook your pages up to the menu(s) (pages 68–69).

17. Create your blog posts and assign them to categories; add tags as well (page 67).

18. Add your sidebar and footer widgets; optionally create different sidebars for different pages if your theme allows it.

19. Add the essential plugins, as explained in Chapter 7: Akismet, Jetpack, Pixeline's Email Protector, All in One SEO Pack, and optionally, Google Analytics for WordPress. Configure the All in One SEO Pack, following the instructions on page 142.

20. Add any other plugins you may want to include.

21. Integrate the social media you want to include on your site, as explained in Chapter 13.

22. Check that you have everything on the site that you need to to keep the right side of the law (a privacy and cookies notice, etc.) as outlined in Chapter 15, referring to local information as necessary.

23. Go to Settings > Reading and uncheck the box discouraging search engines from visiting your website.

24. Launch your site!

25. It isn't over . . . you need to market your site to keep the visitors coming. Plan your ongoing promotion strategy—read pages 146–147, and Chapter 14.

Enjoy showing people the site you have built yourself!

Glossary

Admin area—alias the "back end" of your website. The area you log into to make changes to your site, which is never seen by your site visitors.

Avatar—a graphic representation of you, when you reply to comments left on your site, and the site visitors who've written the comments. To customize your avatar, you need to get a "gravatar" (see page 165) otherwise you'll appear as an anonymous gray "mystery man" or a random graphic square.

Backup—a copy you keep of your website, in case anything goes wrong and you need to set it up again. You should back up your site regularly; luckily there are plugins to do this automatically for you (see page 162).

Blog—an area of your site, or a standalone site of its own, where you post articles, messages, images, links, and other material, which are then arranged chronologically with the most recent post first. This part of your site is usually less formal and more interactive than other parts.

Bookmarklet—a bookmark you add to your browser that performs an action; for example the PressThis bookmarklet (see page 163) lets you post instantly to your blog.

Carousel—a style of slideshow, or way of viewing images, that allows site visitors to see pictures appearing from the side and following on one after another.

Categories—a system of filing for your blog posts that organizes them according to subject matter.

CMS—"Content Management System." This simply means a website that has an admin area that the site owner can log into to make updates, without having to go into the coding of the site. WordPress is the most-used CMS, but there are many other popular systems, such as Joomla and Drupal.

Dashboard—the home page of your admin area.

Database—your database is the program that stores the data from your WordPress website—pages, posts, comments, etc.—on your web host; it works in the background and you'll most likely never need to access it.

Domain name—your web address, for example, www.yourname.com.

E-commerce—accepting payment from your website. This can be done via PayPal or a combination of internet merchant account and payment gateway (see Chapter 8). You will usually need a theme designed specifically as an online store, and one that will work with the payment system you choose.

Embed—to add an extra element, such as a video, to your website so that it appears in the main area of your web page (as distinct from creating a link that the viewer will then click on to be taken to a different web page).

Extension—the end part of your web address. The most commonly seen one is .com, but there are numerous others, such as .me and .tv. This part of a web address is sometimes known as the TLD (top-level domain).

Featured image—an image that shows up in a particular, prominent position for a blog post.

Follow—if you "follow" someone on Twitter or Pinterest, you can view their "tweets" or "pins" on your Twitter or Pinterest front page.

Footer—the area at the bottom of your web pages; you will usually put a copyright notice here, and sometimes you can put widgets.

FTP—to upload to your website without going via your WordPress Media Library. If you need to upload directly (perhaps because of a file size restriction), you can do this via your File Manager, accessed via your hosting control panel, or using special software such as Cute FTP (PC) or Fetch (Mac).

Full-screen—some themes are designed so that photographs or videos are shown at the entire size of the viewer's computer screen—a great way of making the maximum impact.

Gallery—a way of displaying groups of images on your site. WordPress comes with a standard gallery display, but there are other gallery plugins with more complex layouts you can install.

Header—the image at the top of a website, usually containing the logo or the title of the site, though this may also appear separately.

Hex ("hexadecimal") color—a six- or three-figure code used to identify colors used on websites, e.g. #FFFFFF signifies white.

Hosting—the space you rent in cyberspace where your site is built. The company responsible is called your host or your web host.

HTML ("Hyper Text Markup Language")—the basic code used to create websites.

Internet merchant account—a special bank account allowing you to accept online credit card payments. (See "Payment gateway.")

Keyword or phrase—a word or phrase that a person might type into Google or another search engine when looking for information online.

Like—this has a special social media meaning in that if you "Like" a website by clicking the Facebook "thumbs-up" icon on it, in future you'll see the other party's Facebook updates appearing in your activity stream.

Masonry—a style of displaying images that incorporates different sized images in a tidy grid.

Micro-blogging—posting either extremely short bulletins or images using Twitter or Tumblr, or a special blog post format (e.g. quote, aside, link, audio) other than the normal more lengthy "standard" format, on your own blog.

Payment gateway—the interface between your website and your internet merchant account. Some payment gateway companies can provide, or help you obtain, an internet merchant account. (See "Internet merchant account.")

Permalink—the website address of each page or post on your site.

Pingback/trackback—different notifications you may receive to notify you that another website owner has linked to content on your site.

Plugin—an "extra" you can add to your WordPress site to enhance functionality. For example, you can install a plugin to display a calendar, a contact form, and so on. A plugin can also be used to perform behind-the-scenes activities, such as making backups or filtering comment spam.

Portfolio—as distinct from the built-in gallery feature that you can use to group images together, some themes come with a built-in portfolio feature that is expressly designed to showcase work. This kind of portfolio usually allows for details to be added to pictures of works and are very often "filterable," meaning that you can group your works into different categories and site visitors can choose to view them accordingly. The layout options available to you will vary from theme to theme.

Post—an item you publish on your blog that will be displayed in the blog area of your site with other posts, as distinct from a static "page," which is a stand-alone item.

Registrar—the company who registers your domain name for you, by the year.

Responsive—some themes adjust their layout to fit the screens of a tablet or smartphone. For blogs and portfolios this may be important so that your material can be easily read or viewed.

SEO (Search Engine Optimization)—the practice of preparing your website for the best possible ranking in the search engines.

Share—apart from the obvious real-world meaning, in the website world to "share" means to publish a weblink or other element from another website your own social media page (Facebook, Google Plus, etc.), so that your own network can see it.

Sidebar—column on the right or left of your web pages to which you can add widgets. (See "Widget.")

Slider—a large rectangular viewing area, usually on the home page, that allows site visitors to see a series of images. These often have arrows, dots, or thumbnails allowing the visitor to view the images as they please; often they cycle automatically. Sometimes images in the slider link to other pages of the site.

Social media—a global term for networks such as Facebook and Twitter that allow users to message each other and share material such as images and videos.

Spam—also known as "UCE" (unsolicited commercial email). Junk messages received by email, or by people leaving "comments" on your website. There are tools to prevent this being a problem; you should also take care to stick to the rules (see page 161) when sending out email newsletters to make sure you aren't accused of spamming yourself.

Sticky post—a blog post that is set to always show at the top of the list of blog posts, so that it remains visible to readers. This may be a particularly popular or useful post, or may contain important information.

Subscriber—a person who has signed up for or agreed to receive email updates from you either in the form of newsletters or blog posts. (People can also "subscribe" to blogs using a feed-reader such as Feedly; a tool such as this allows readers to keep up with all the blogs they follow via a single interface. An "RSS"—"Really Simple Syndication"—feed is simply the name for a news or blog feed that can be followed in this way.)

Tags—keywords and phrases you can attach to your blog posts.

Theme—the template you choose for your website that will determine many aspects of its design and layout.

Thumbnail—a small version of an image, usually clicked on to display a larger version.

Tile—to repeat an image so that it completely covers an area, sometimes seamlessly.

Tracking—observing and analyzing the statistics of your website visitors: their geographic location, which search terms they used to find your site, how long they stayed, etc.

Traffic—the people who visit your website.

Tweet—a message sent via Twitter.

URL—website address.

Visits— the number of people who come to your site, as distinct from "hits." A "hit" is counted each time an item, such as an image, is viewed on your website—these don't have any real value as visitors are what the website owner is interested in. These can be tracked using a system such as Google Analytics (see page 93).

Web host—see "Hosting."

Widget—an element, such as a search box, the titles of your latest blog posts or your latest Pinterest pins, that you can put in a sidebar (side column) or footer (bottom part of a web page).

Index

Index & Acknowledgments

ACKNOWLEDGMENTS

With my thanks to my editors at Ilex Press—Nick Jones, Ellie Wilson, and Zara Larcombe—and to Anahita Rezvanirad, Laura Hodgson, and Pat Gilmour for inspiration, suggestions, and advice. As ever, thanks also to my clients and workshop participants for their encouraging and enthusiastic input.